collect raindrops

THE SEASONS GATHERED

For Jay T. and Finn and all the summers we will share.

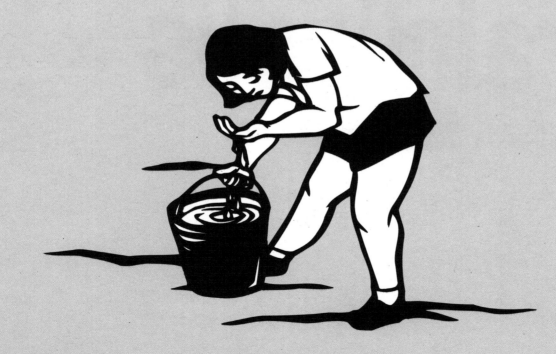

collect raindrops

THE SEASONS GATHERED

Nikki McClure

Abrams, New York

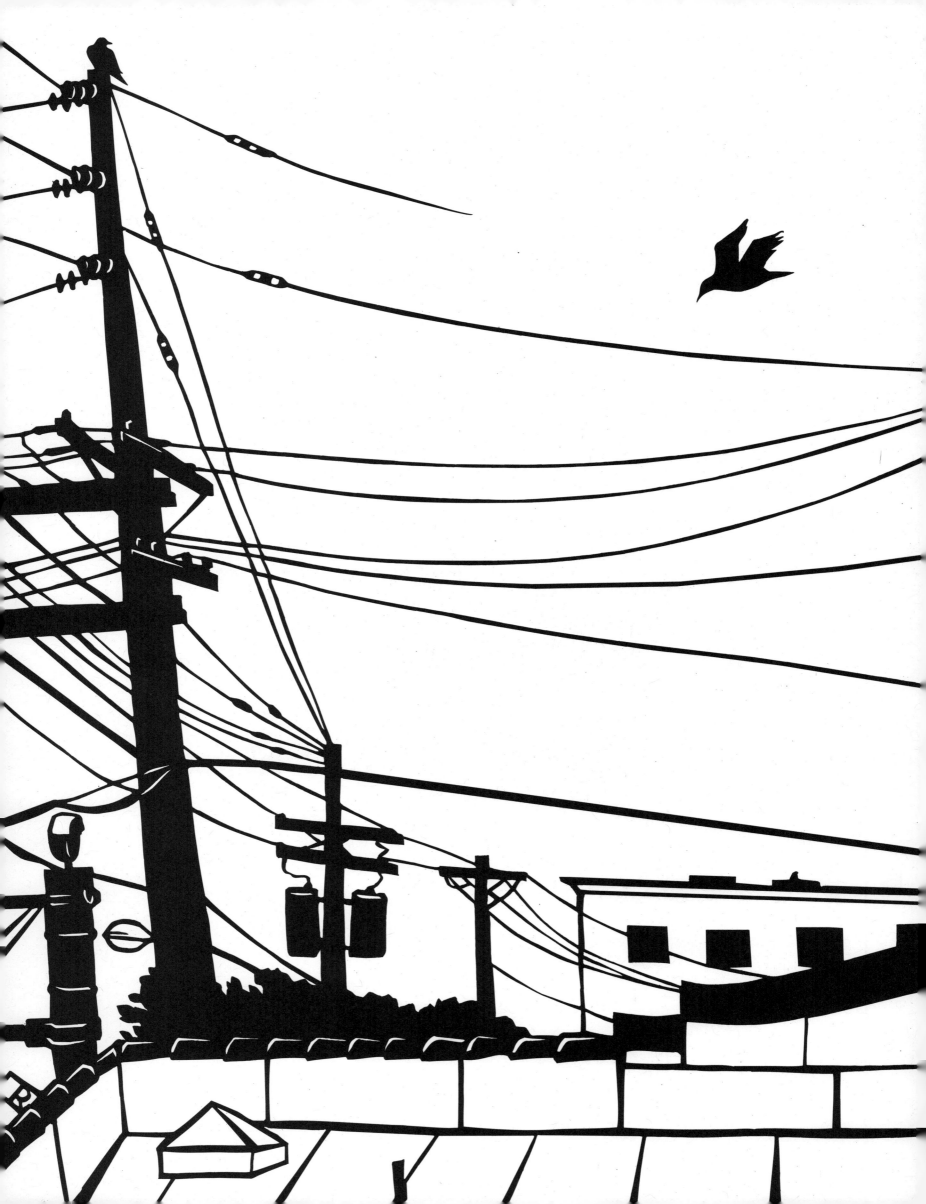

THE SEASONS GATHERED

Every year since 1998, I have printed a calendar noting the month-by-month change in orbit. My first calendar offered small and quick gleanings with every month. The calendars have now evolved into detailed, yet sparse instructions on living life where our hands matter.

I make my pictures by cutting away at black paper with a knife. The paper becomes lacelike and everything connected. What remains is a paper-cut, just black and white. Color and text are added later. My words are letter-pressed or cut out by hand.

I have tried to keep the designs as organic as possible with evidence of my own working hands. The art I made for the calendars from 1998 to 2007 is collected herein. The images are arranged seasonally, beginning with winter, because that is where I usually begin.

There is always something to celebrate, whether it is the first green tip of a snowdrop pushing up or the gathering of sun-crisped shirts fresh off the clothesline. There are flowers to count and fruit to harvest.

Be conscious and hold on as we spin around the sun one more time.

Nikki McClure

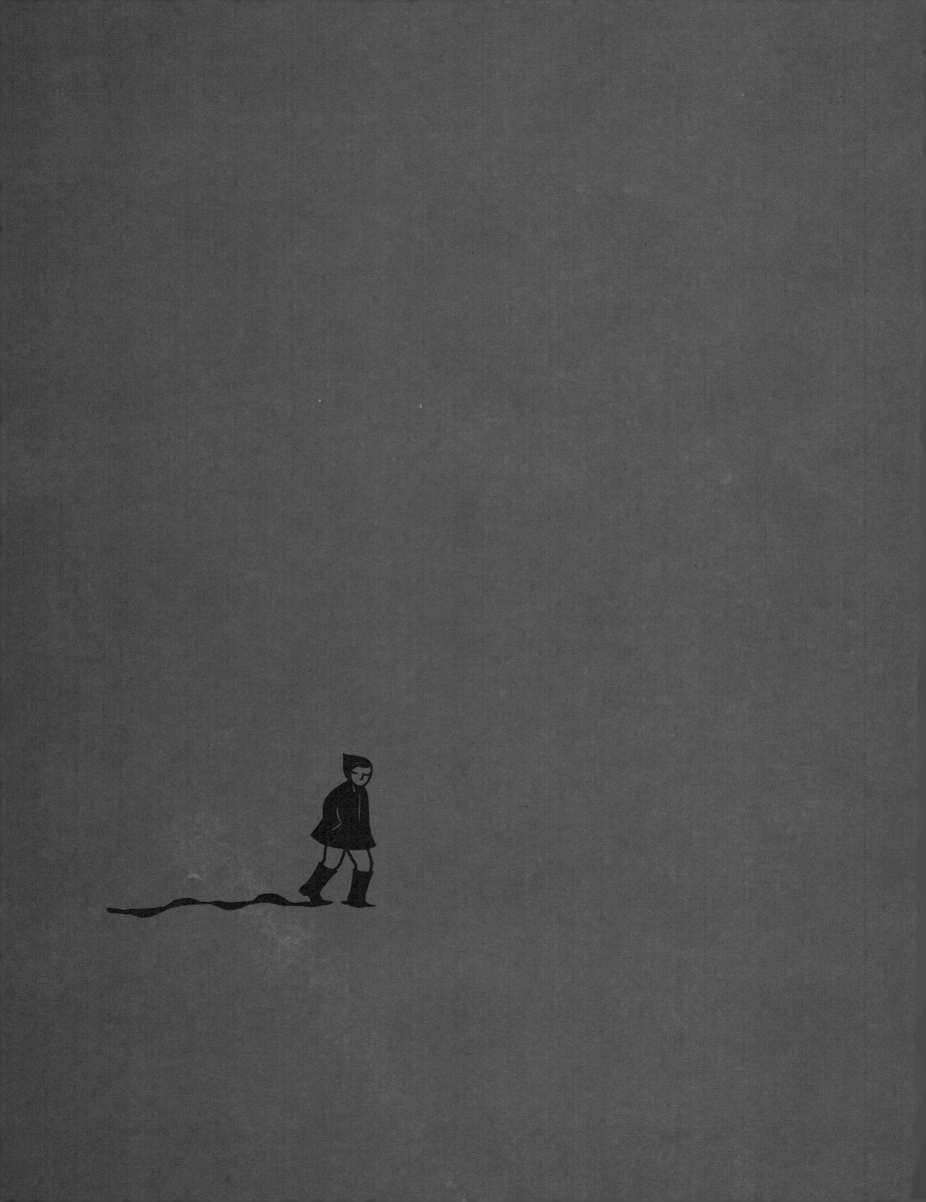

WINTER

Begin to search for a new direction, but first keep the warm air trapped under the comforter for a few more sleepy minutes. Eyes open and close and open. Branches slowly come into focus and a list is made of all the things to make and do for the next 1,000 years. Warm air is released. Try to keep some near by quickly dressing in layers. The teakettle is on and the griddle heats up. The eggbeater whirs to a stop with egg whites risen high. Pour the batter over the entire griddle, why flip more than one? Sprinkle frozen blueberries all over and put an extra handful in a bowl to be shared by all. With each berry, sweet sunshine shimmer is remembered, when hats were lost, buckets too full, and we wove crowns of grass in the shade of the towering bushes.

Outside there is mud and ice, rain and snow. Dark pine needles and swordferns curl, evergreen and solid; only the foggy morning softens their edges. Bare branches hold their buds tight, but there are always some who show cracks of spring's green. There is a quiet stirring. Sap begins to run and the ice starts to drip and race away. Tough kale and tender nettle poke through the frosty morning. Steam vapor rises and eyes meet from under hoods. Snowdrops push up and hang their white lanterns to guide us back home.

Light is hard to come by. We make do with what there is to the shrouded days. At night we have to generate our own light, make our own heat. There is energy to burn. Dance party, bonfire, the oven is hot! Make love, bake a pie or two to share, hold hands, soak in the bathtub all night long. Family and friends are gathered and the dinner table grows. We'll use cups for soup bowls, share tales, and dream up actions. Conspire. Stitches are sewn. History is recounted and constructed as the quilt grows. The candles are blown out and wishes made.

Stories are read and then it is time for more slumber. "Spring is almost here," we dream. Shhh! Wake up and peek out the window to see if snow has fallen. Shhh! We dream some more.

embark

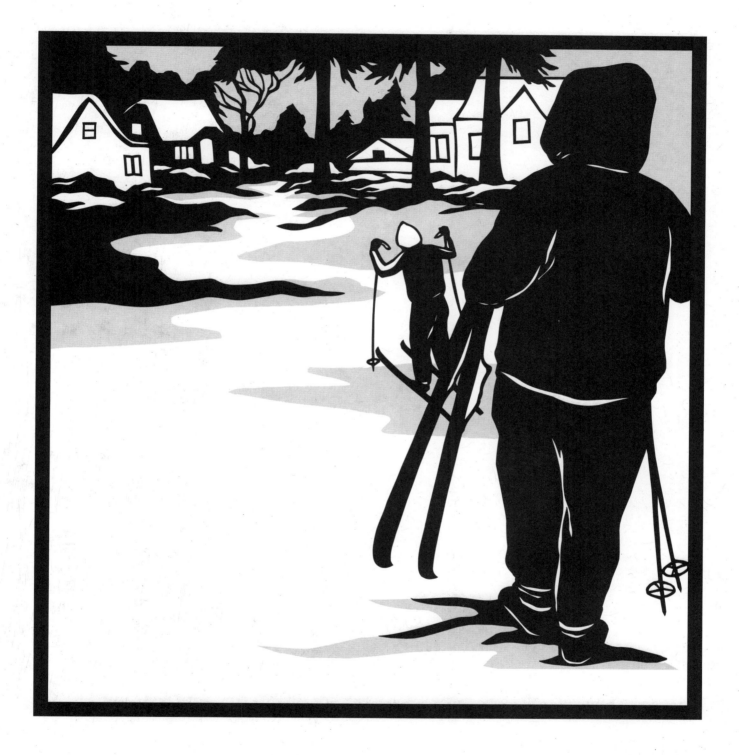

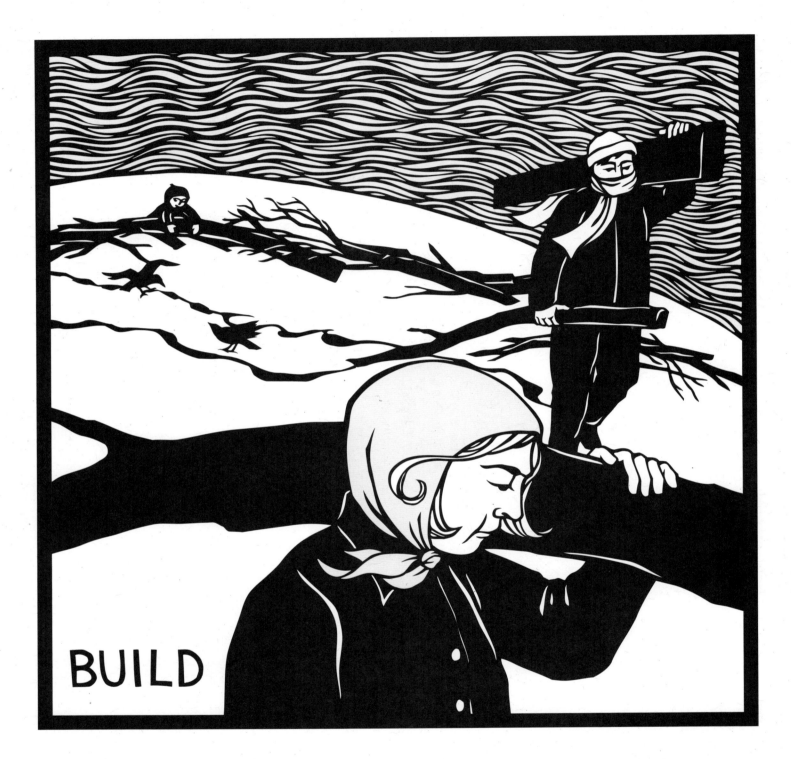

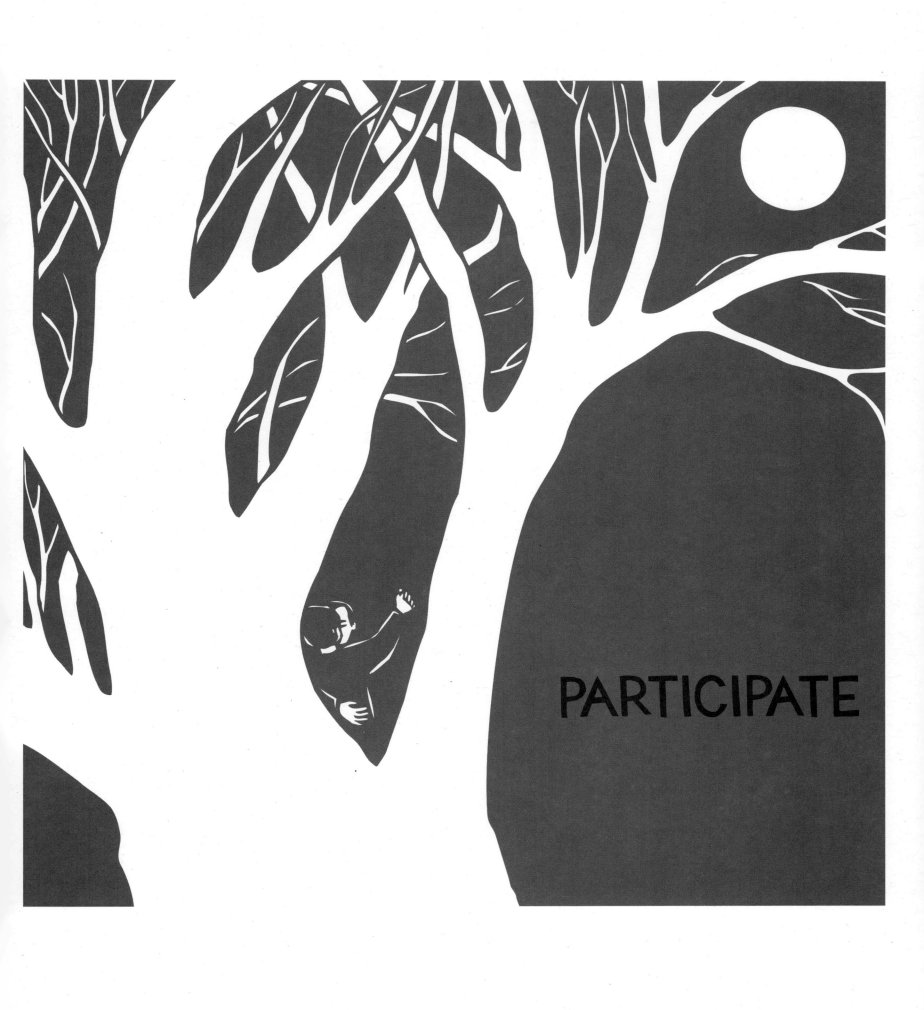

TRANSCEND

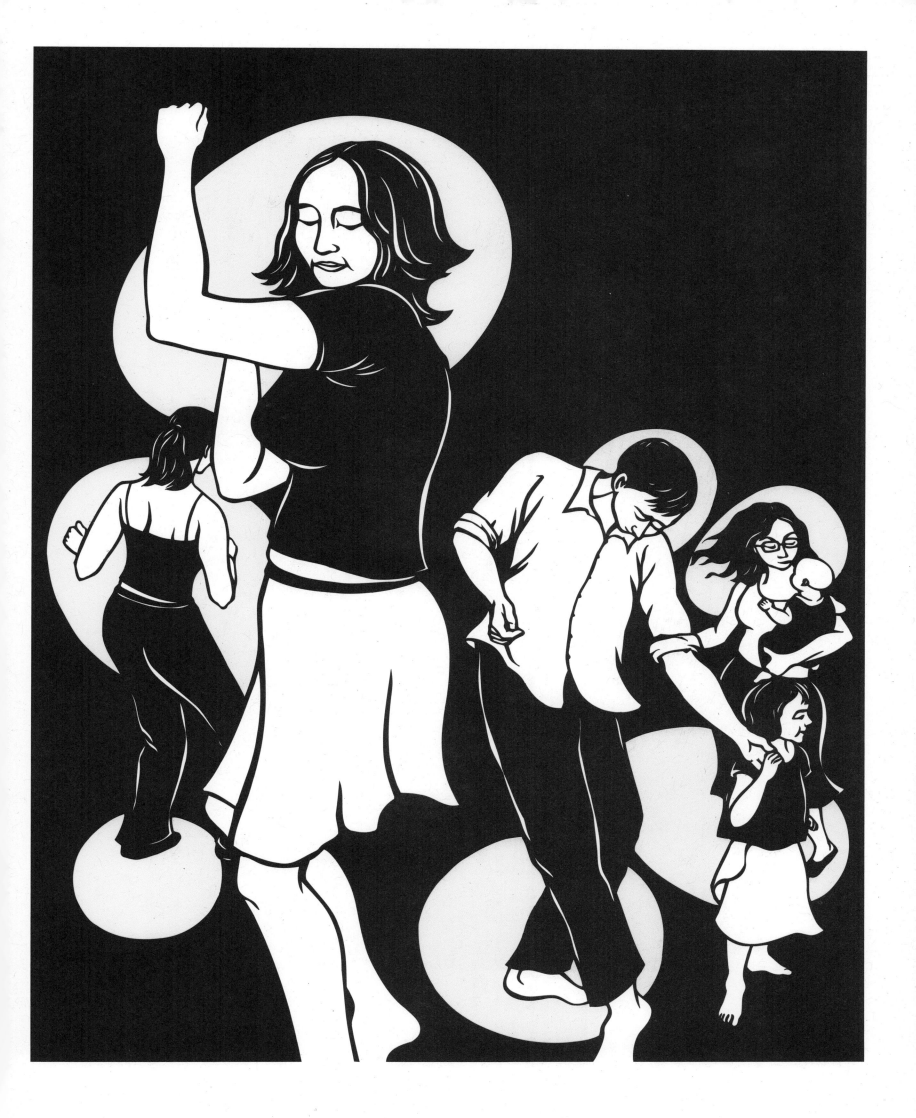

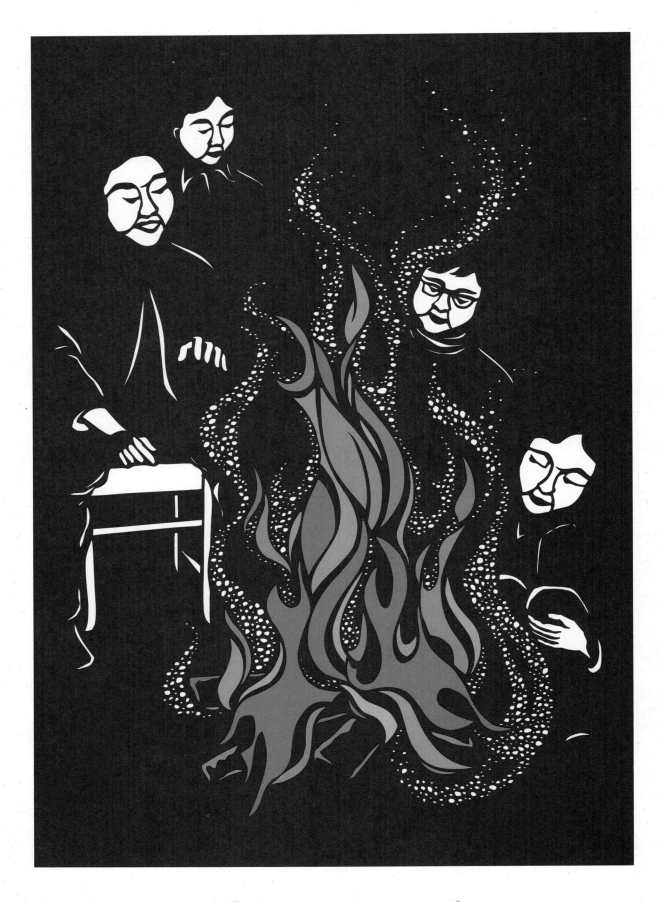

make it bright

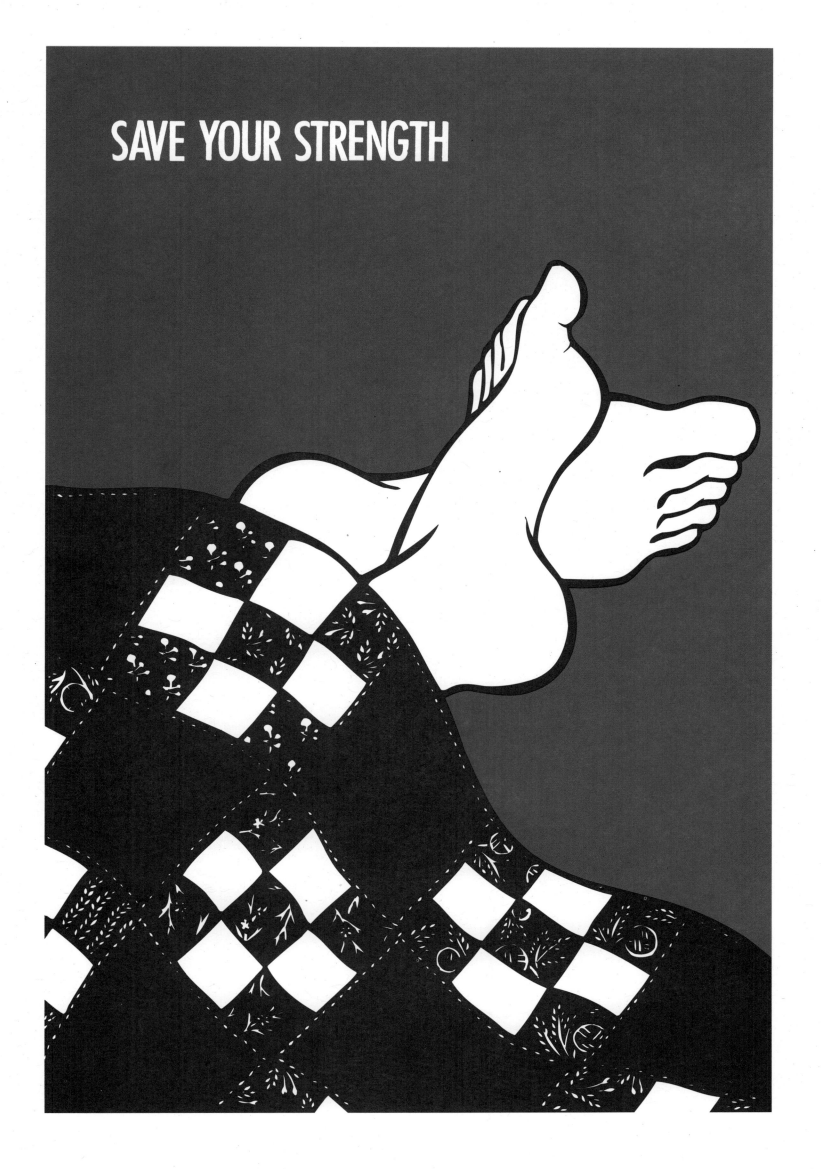

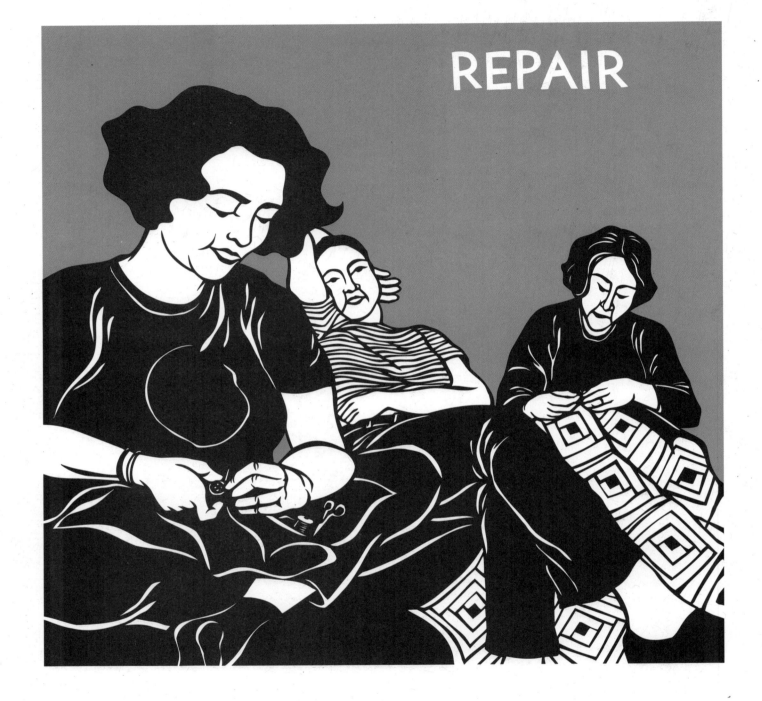

REPAIR

sew stitches

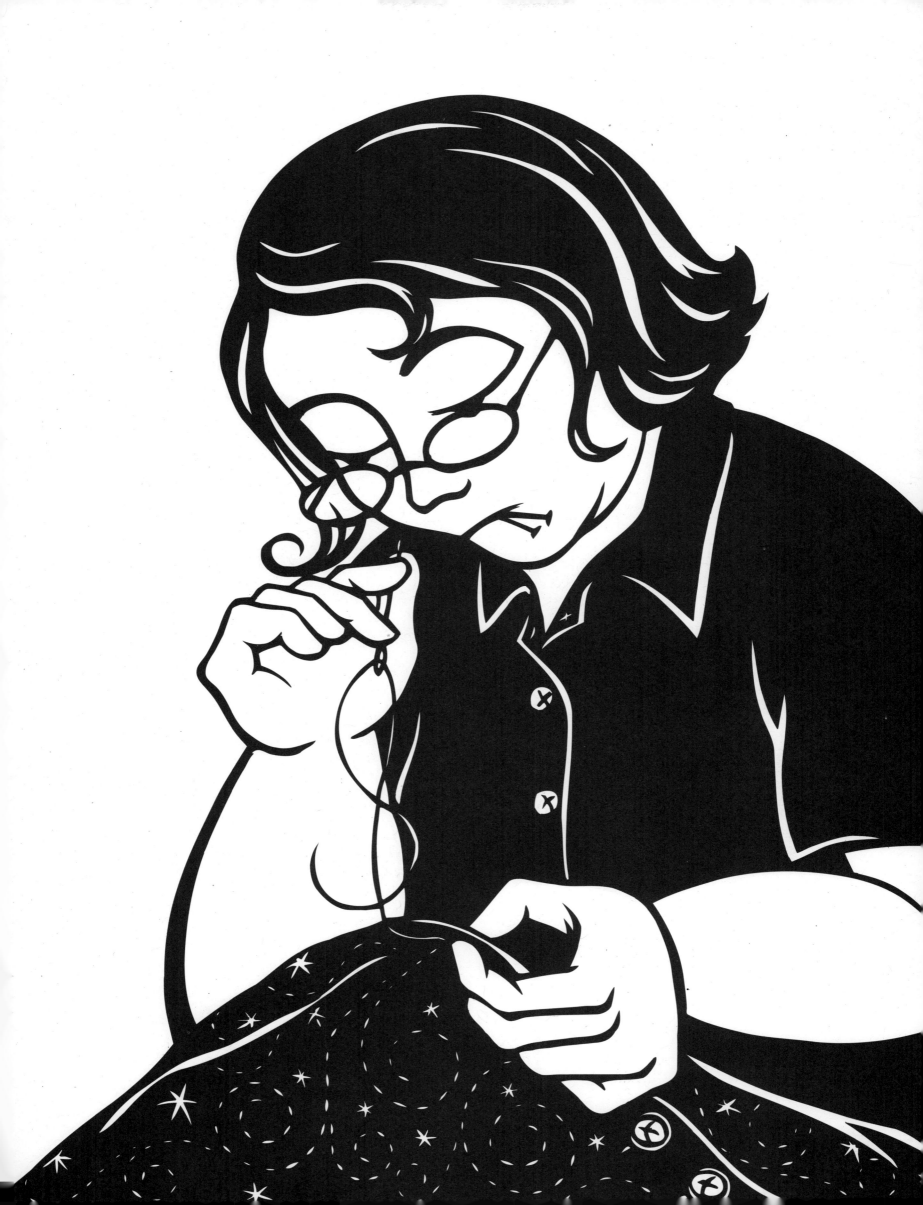

be attentive

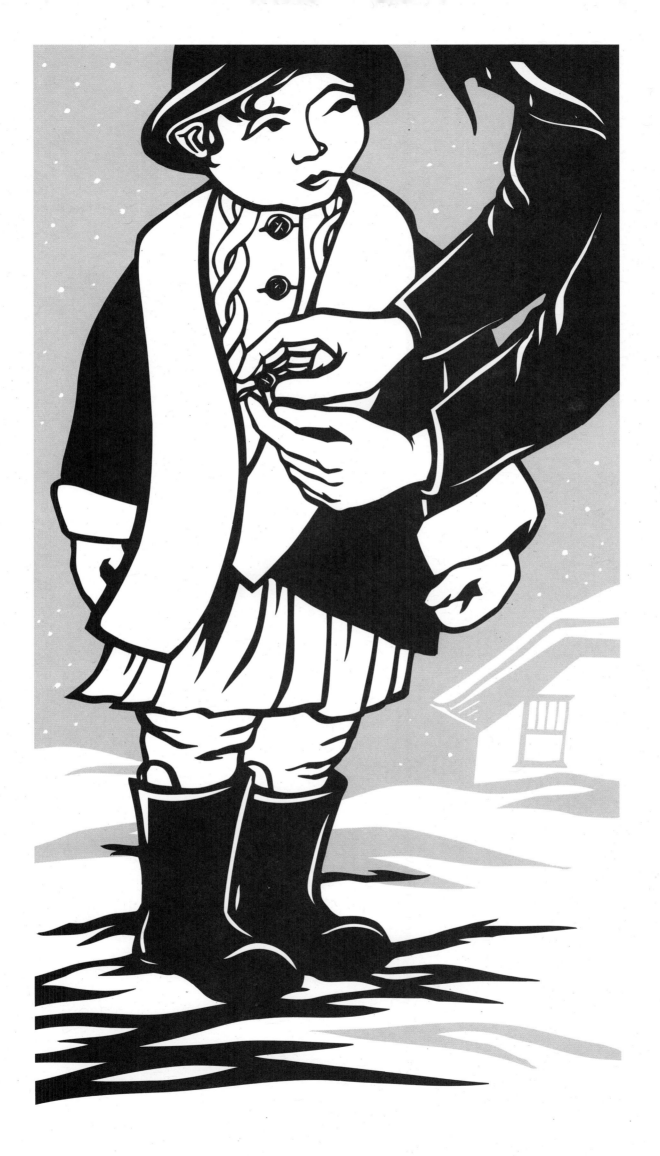

GIVE IN

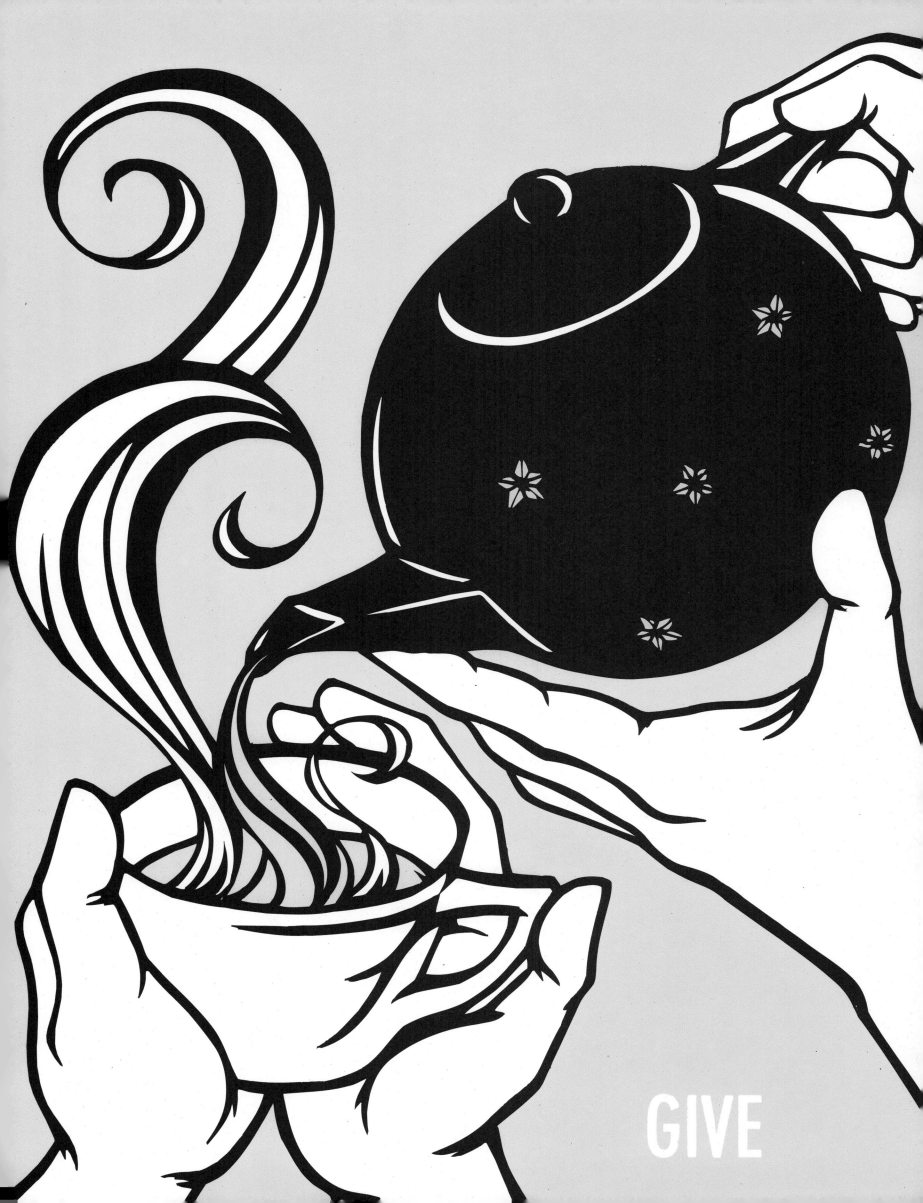

GIVE

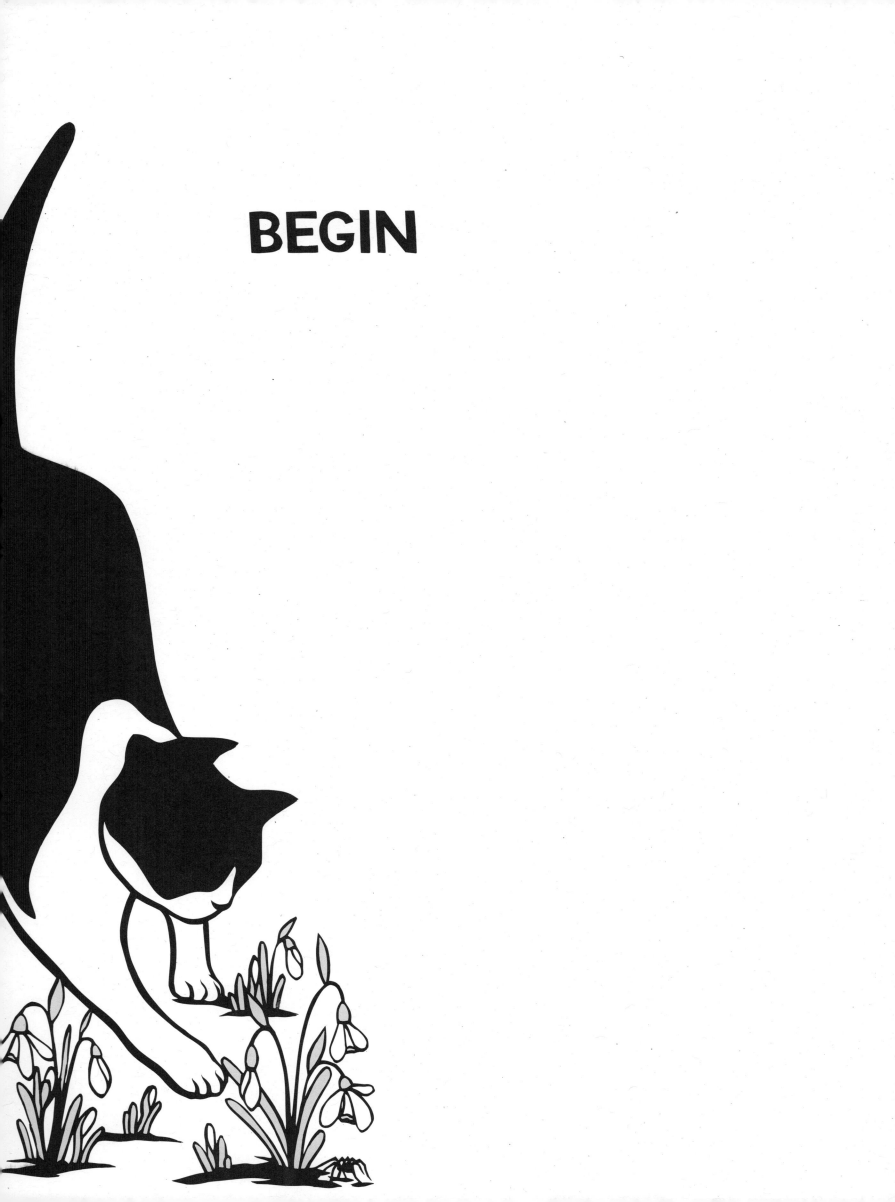

BEGIN

TEND

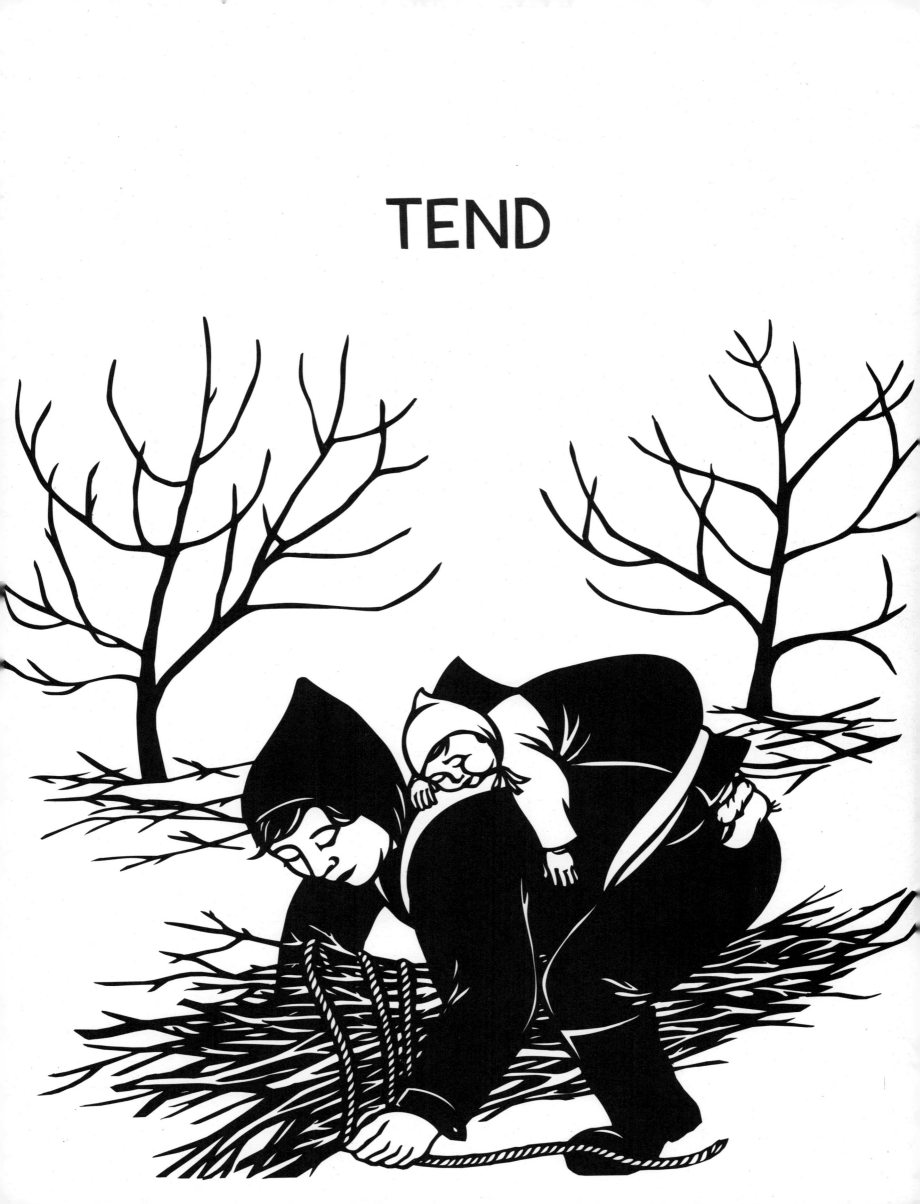

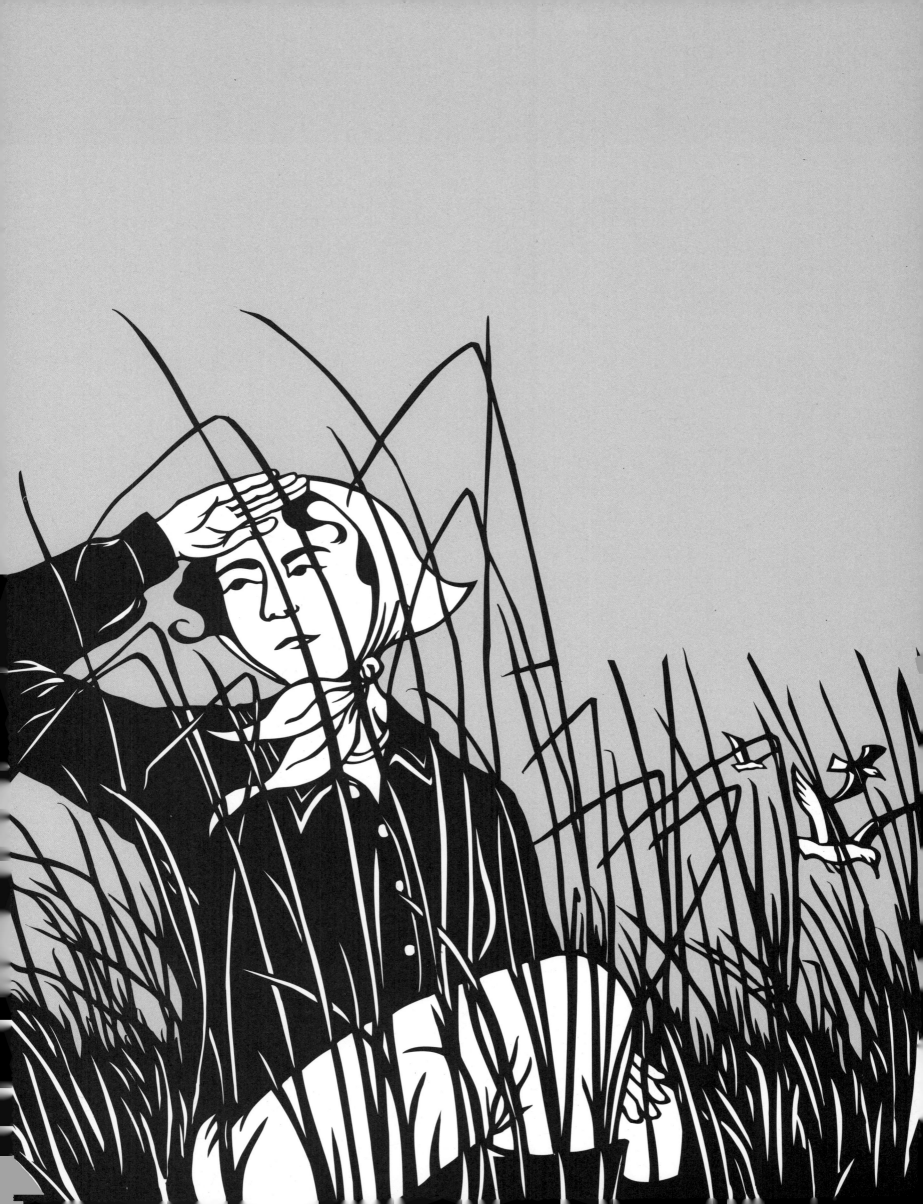

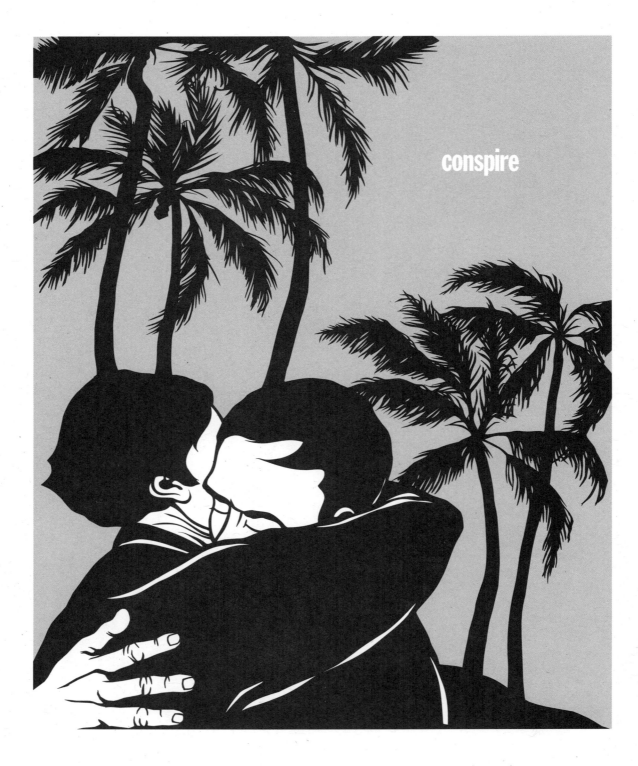

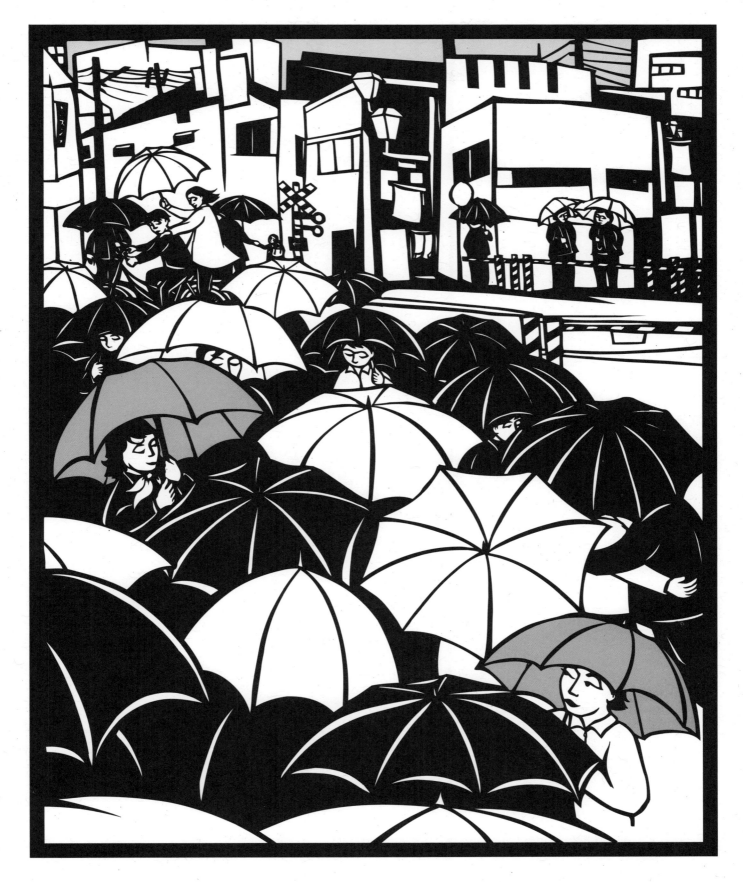

SHELTER TOGETHER

RADIATE

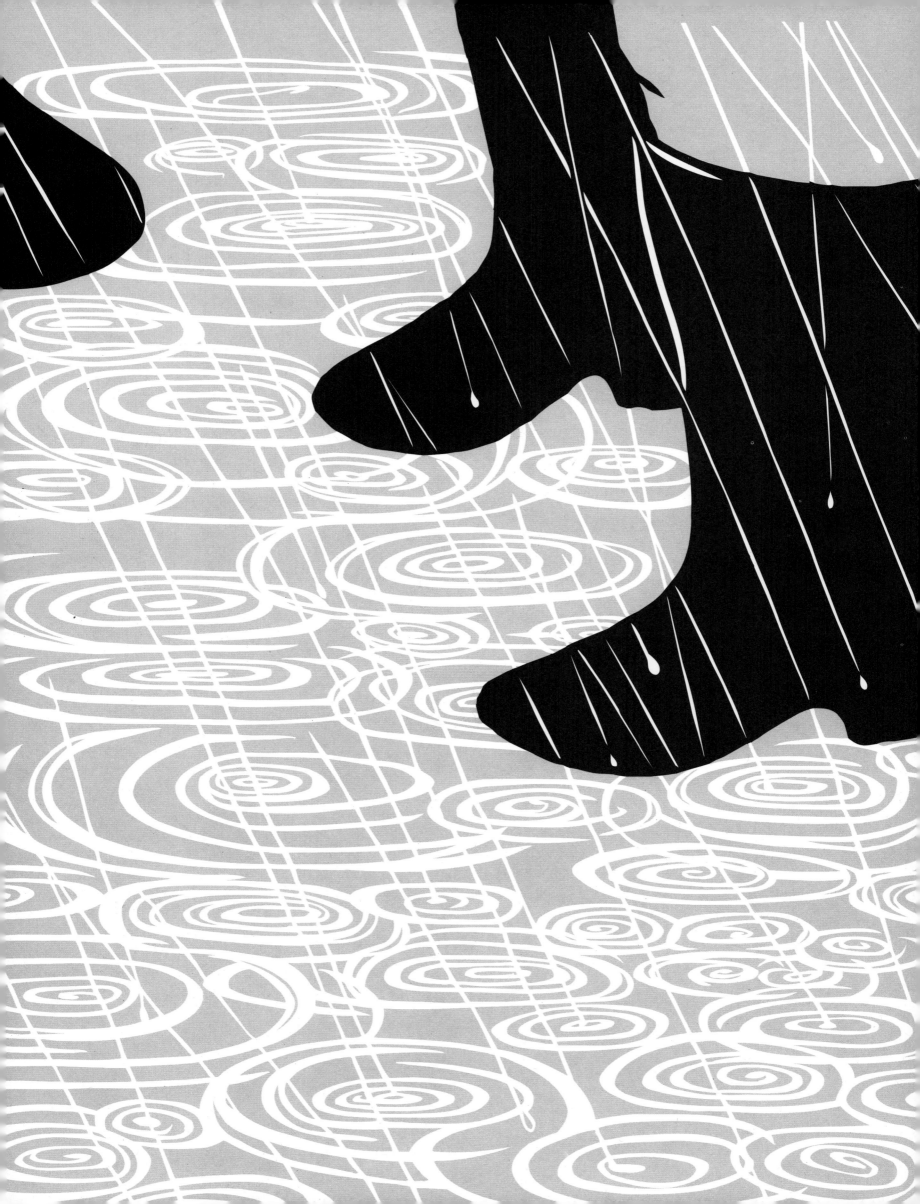

COMMUNE

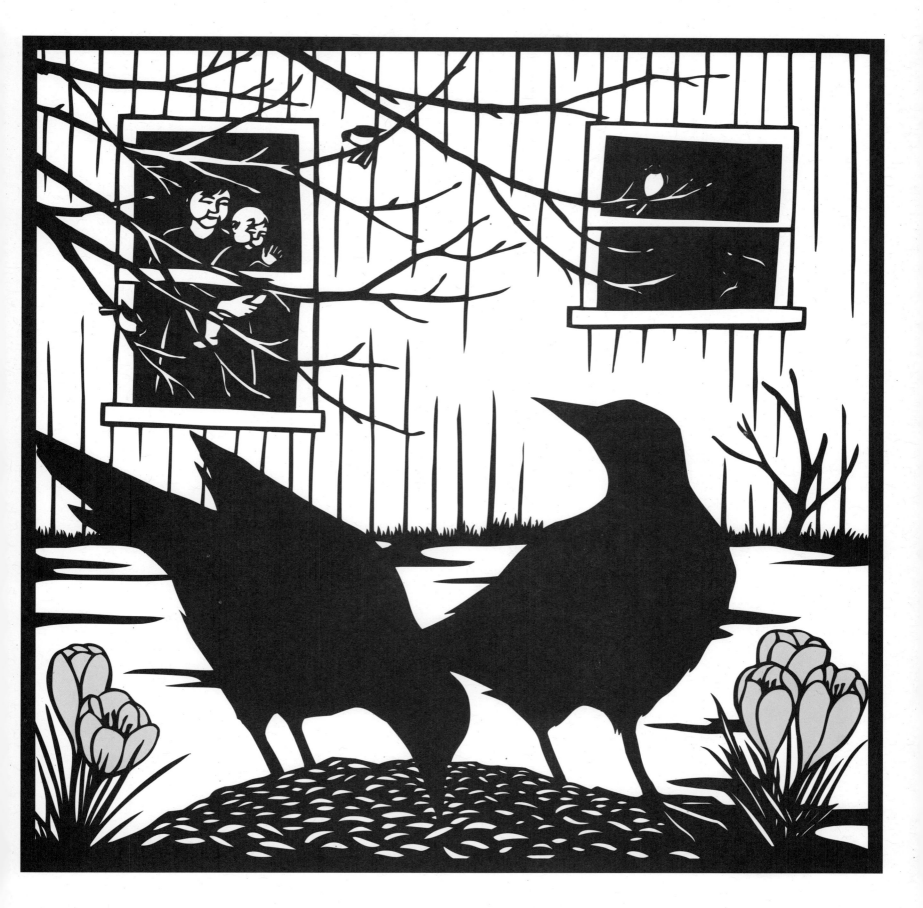

TRANSMIT

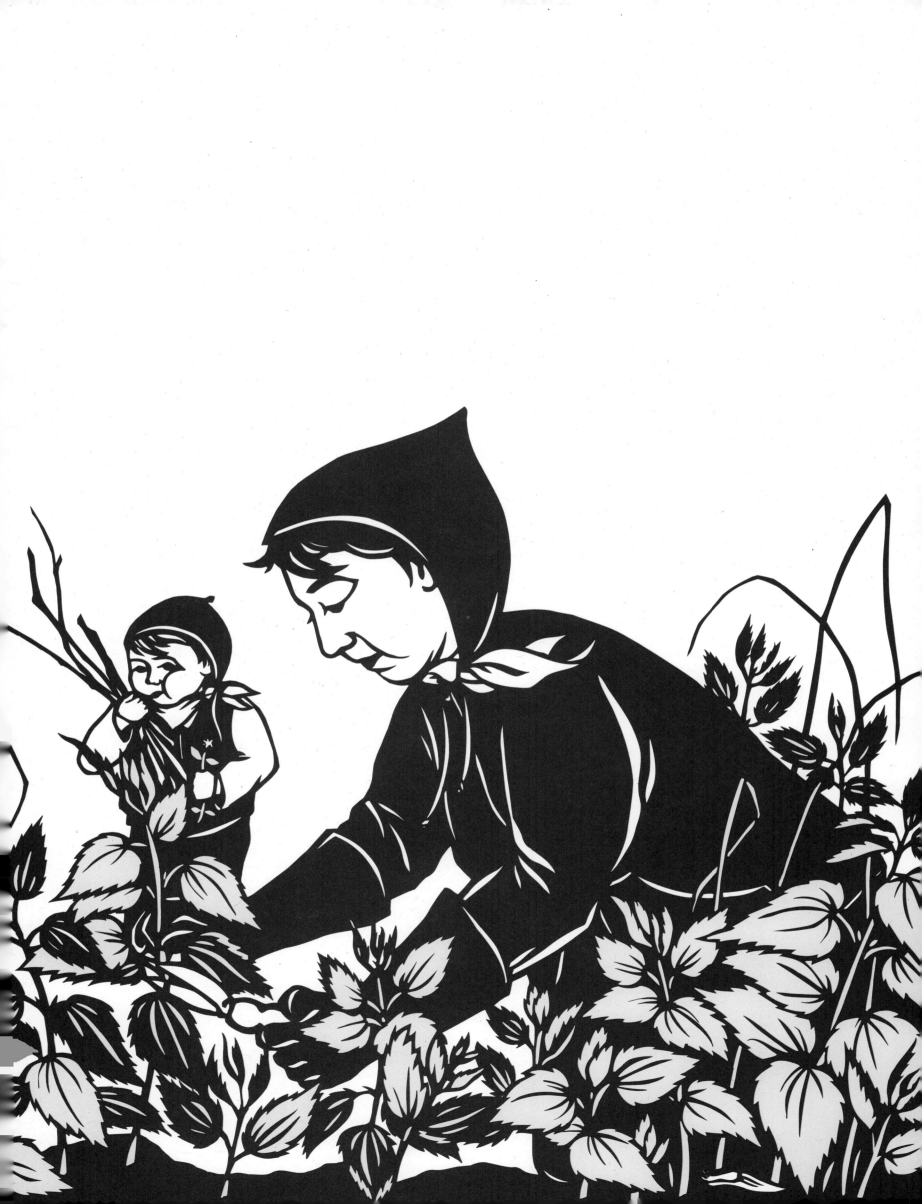

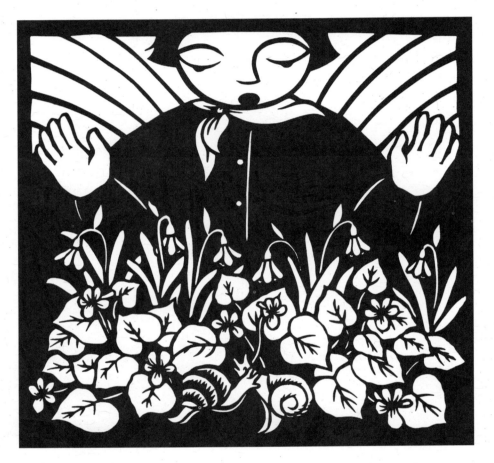

Violets and snail love shake spring awake.

SPRING

The sky opens up and the world is winged. We are ready to be awakened with our health and spirits restored. We take action, forcing branches to bloom. We are all too eager to seize any sign of spring, any sign of winter's end. The earth is turned over and under. Stalks are buried and new seeds planted, fed by winter's remains. Potatoes are laid in and the garden bed is ready. The dirt under fingernails is untangled from roots now free to be made into nests. Spring is in the making.

Listen! The air is alive with flight. Robins descend and descend and descend. Wasps scrape away wood to build new hives. The wind stirs new leaves and transparent light shines through the green energy. Sap flows fast. Hearts pound. Colors explode in yellows, pinks, purples, and reds. Petals open wide to all you bring. Everyone participates in the pollination. Honeybees welcome each pea blossom and every day there is a new birth to celebrate. Feel the pulsing life in every tree, in every heart. Release the stirring energy. Sing your own songs to wake up the birds.

Work together to increase tilth. Summer rewards the work done in spring. So get at it, grab a shovel, raise your flag. Conceive.

EAT MORE KALE

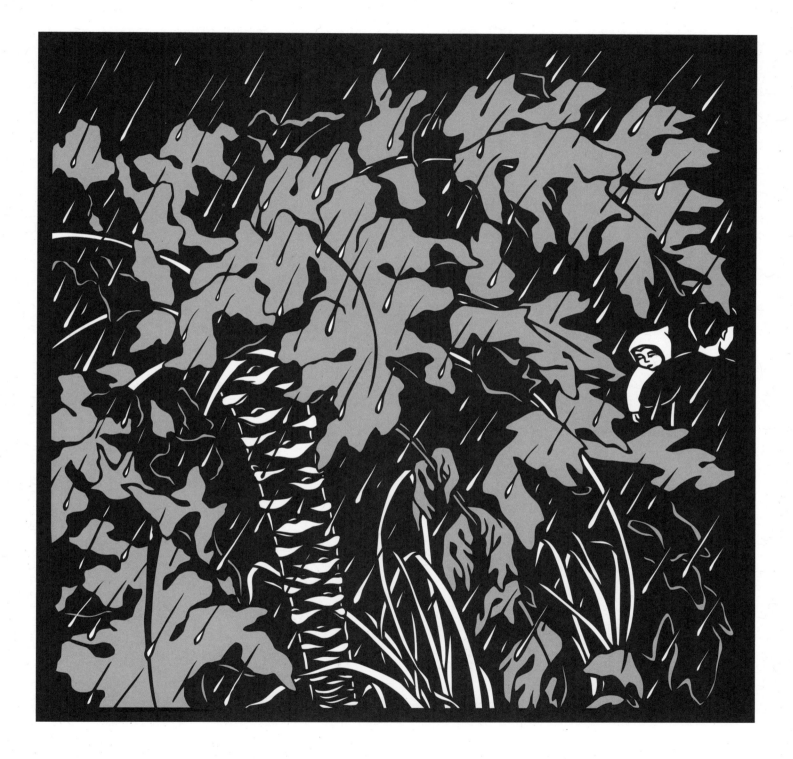

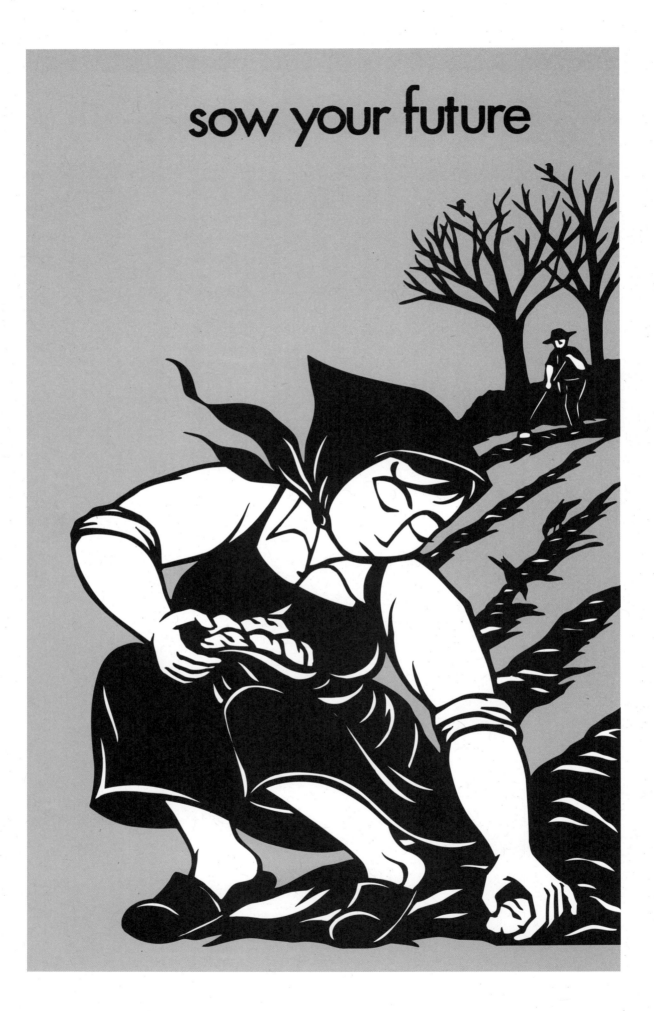

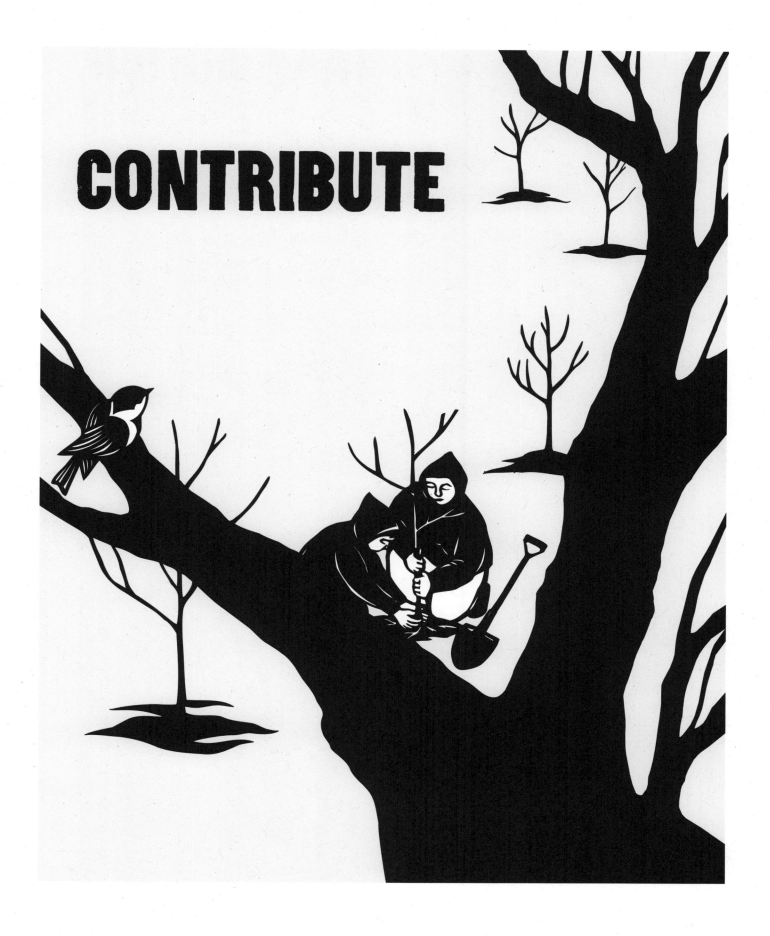

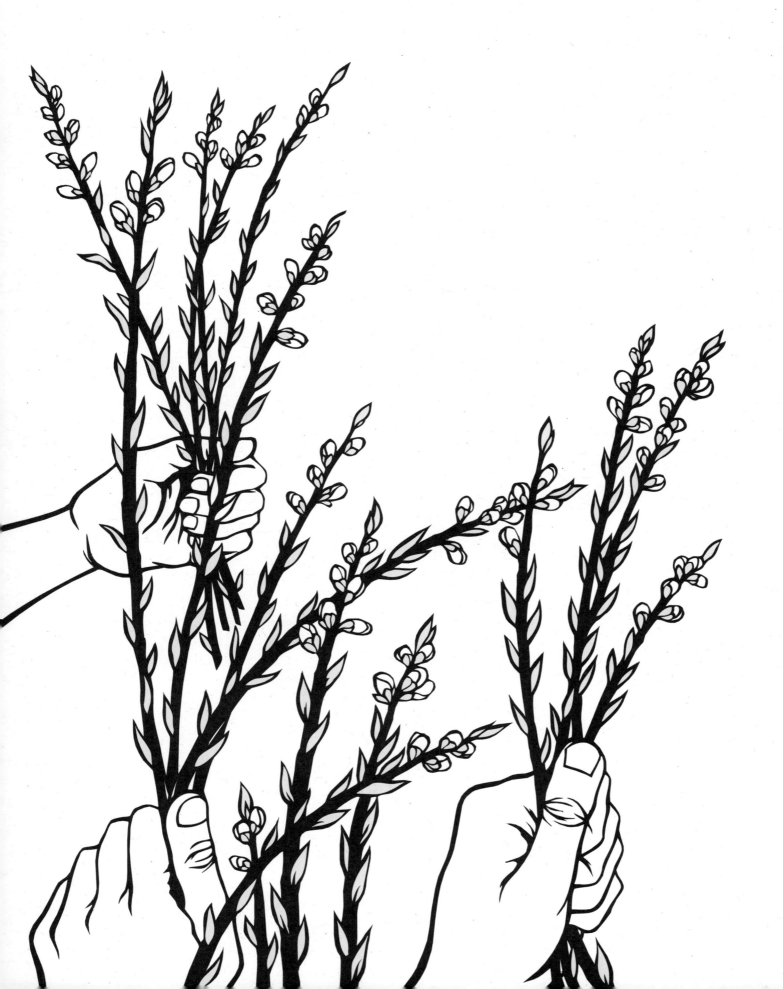

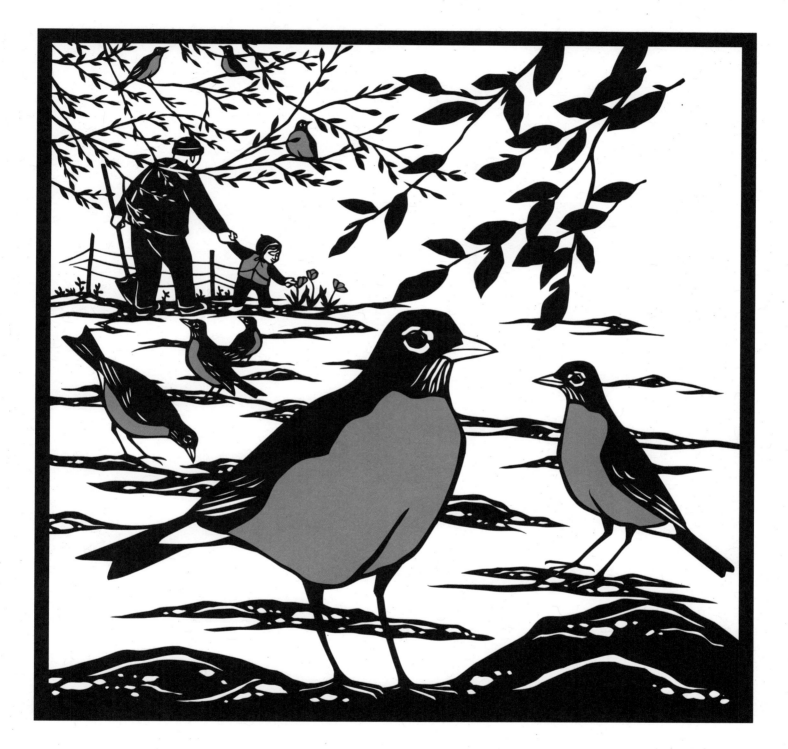

WAKE UP !

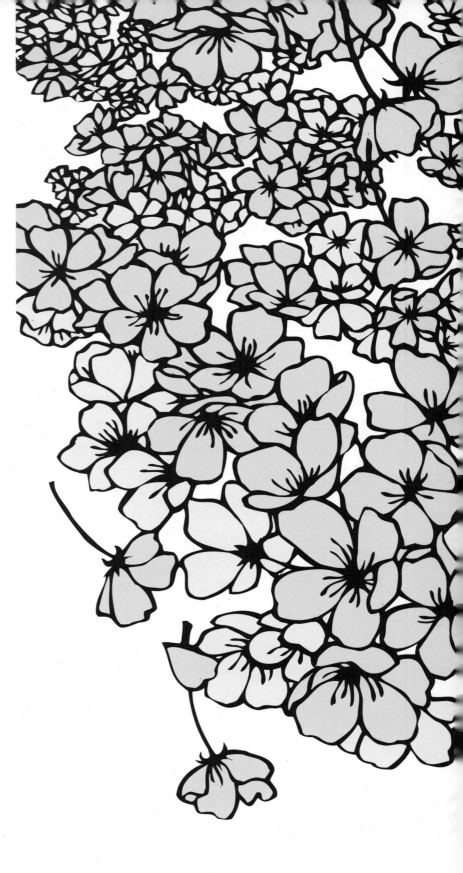

a new materialism

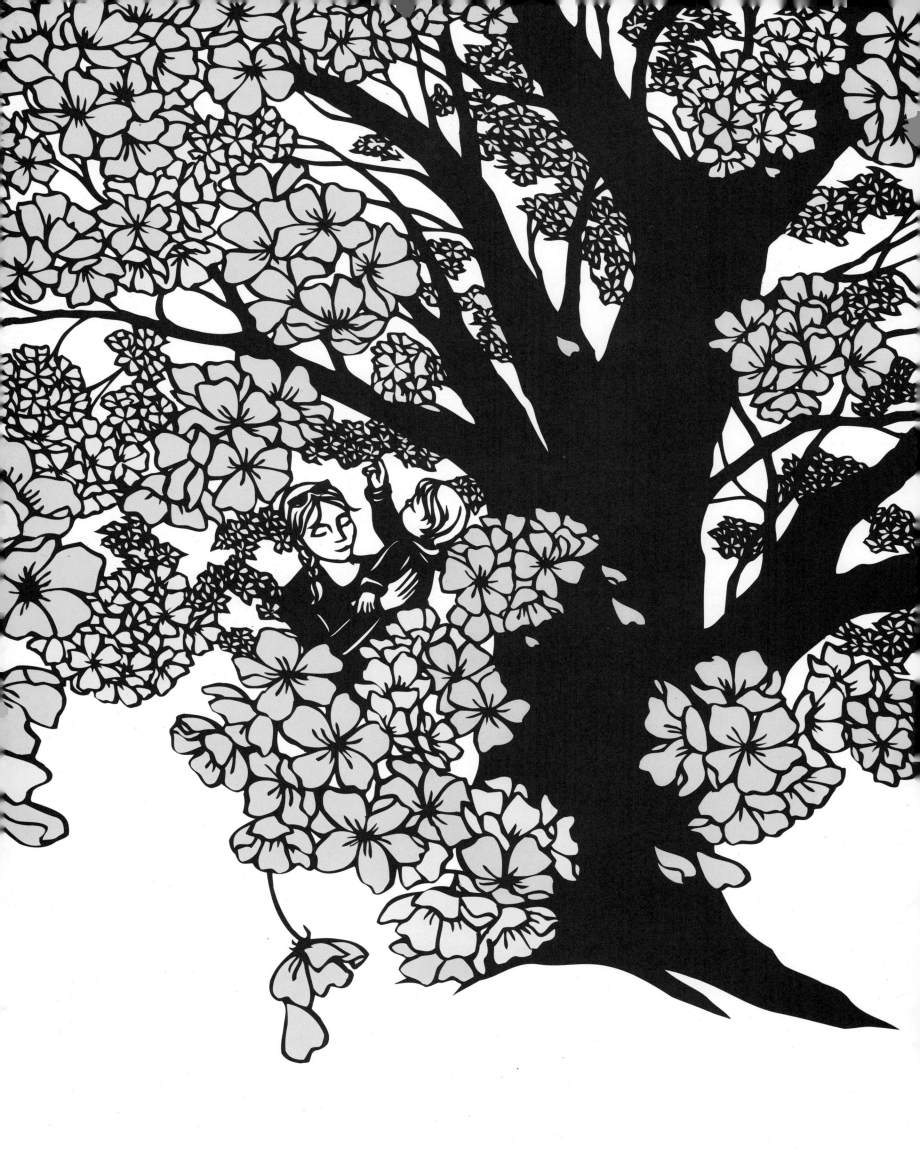

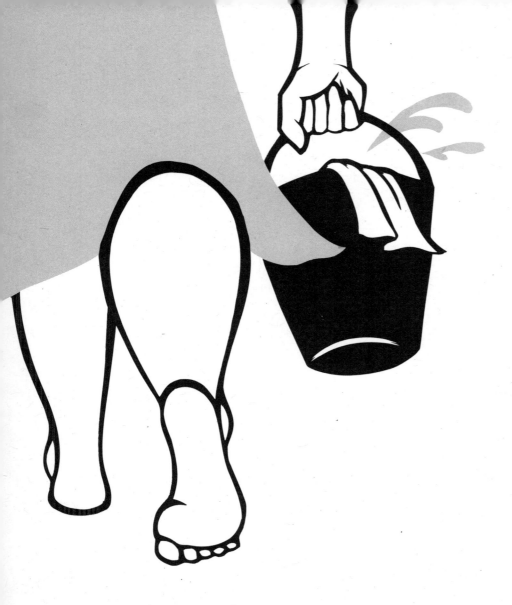

CLEAN

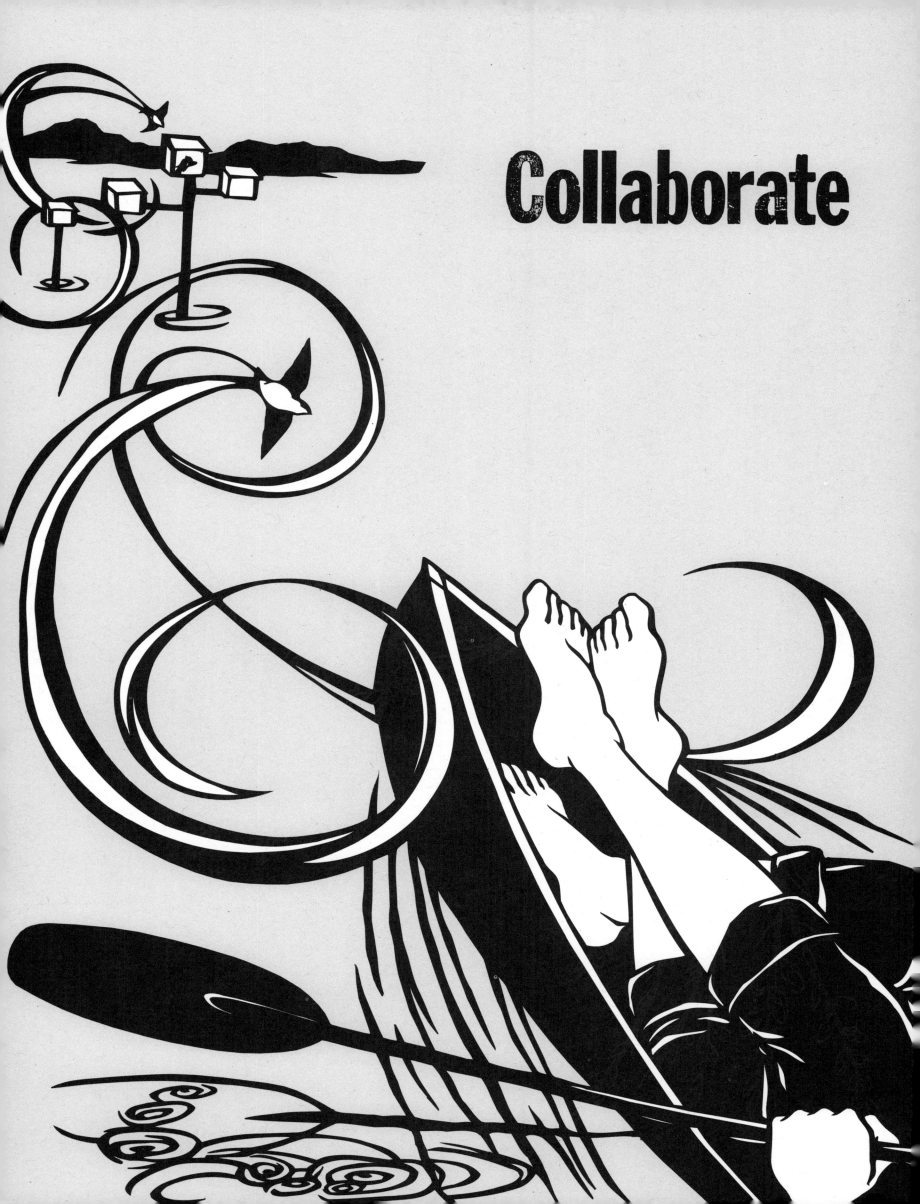

Collaborate

PREPARE

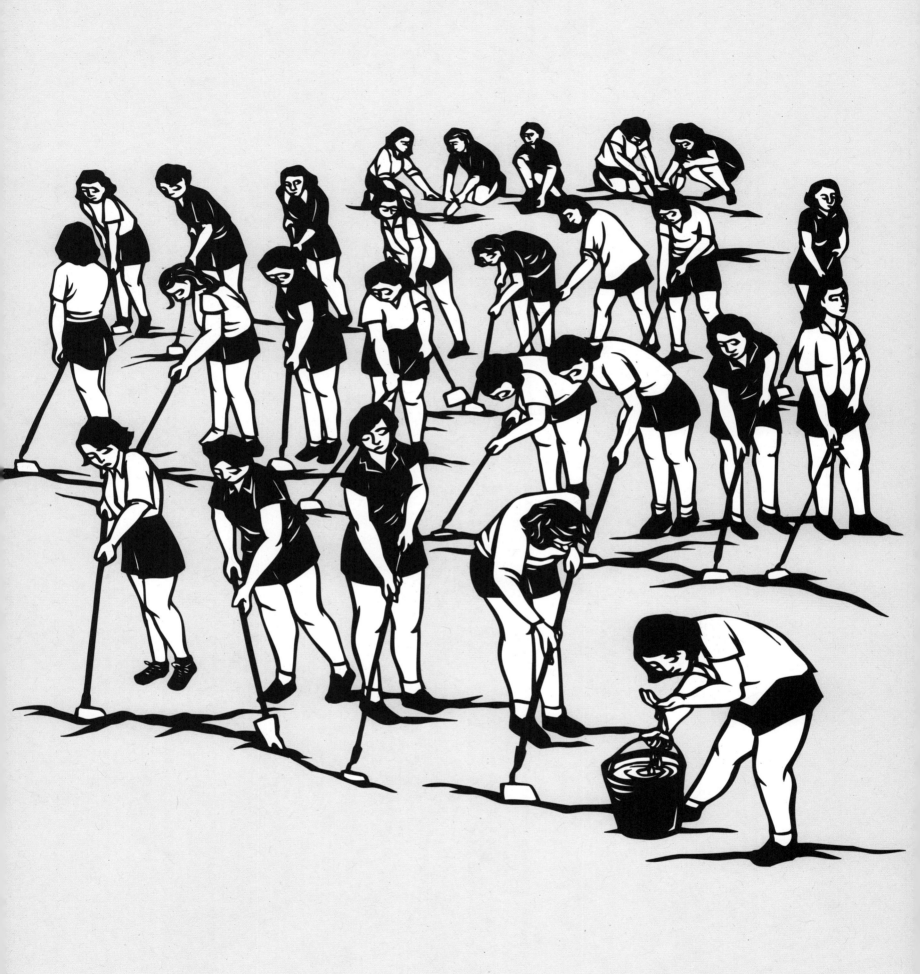

COURAGE

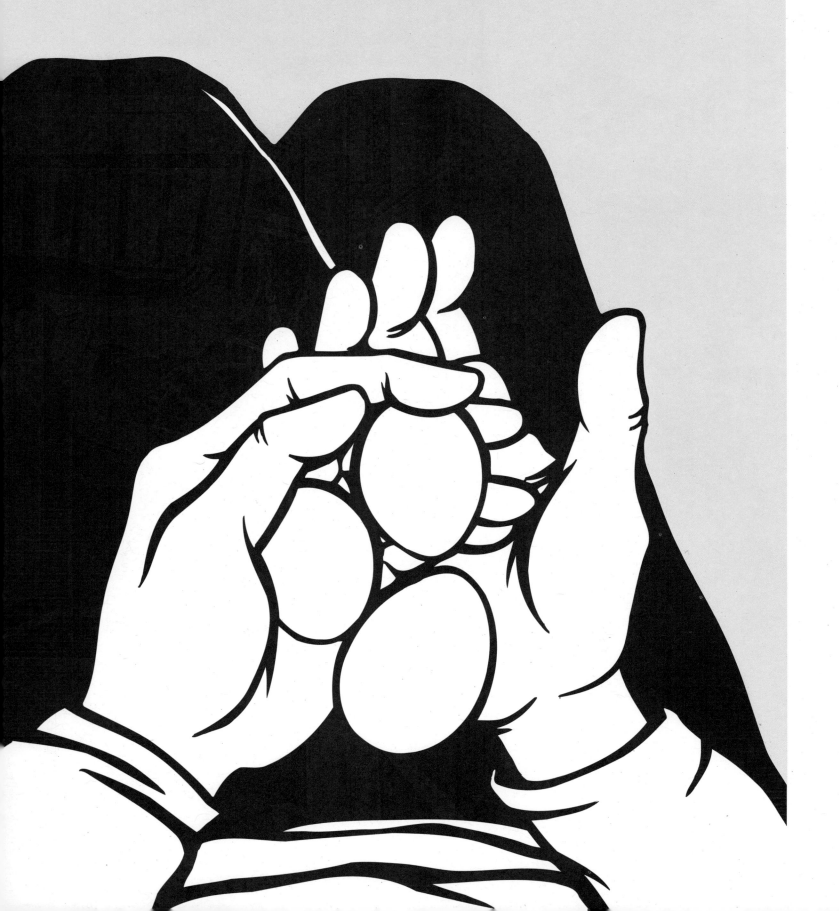

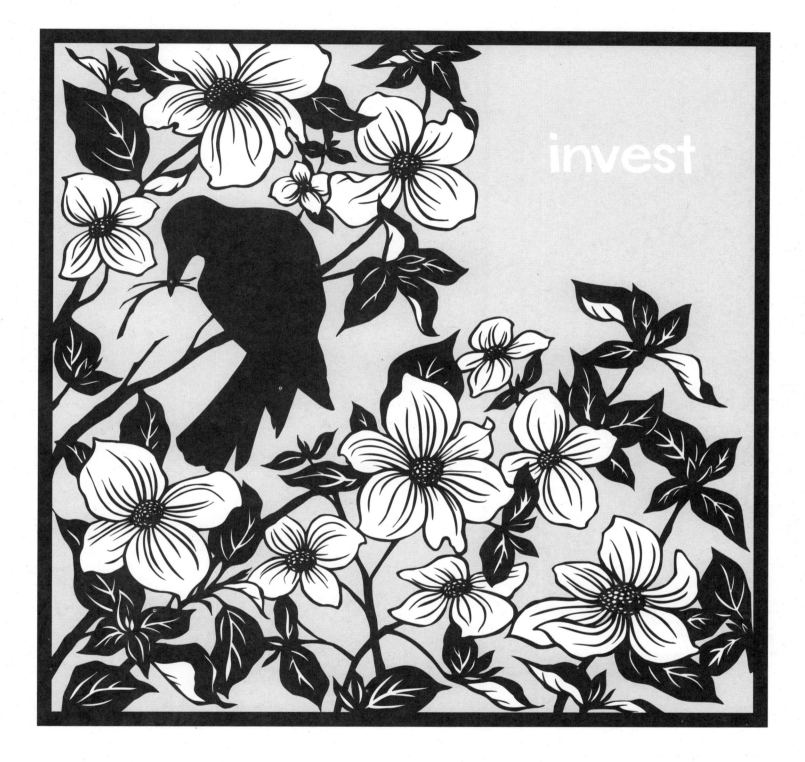

invest

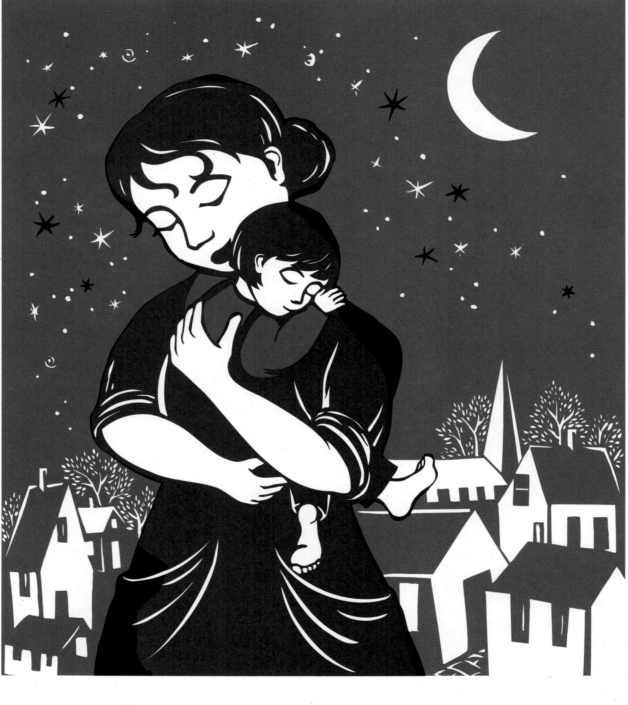

Sing a lullaby

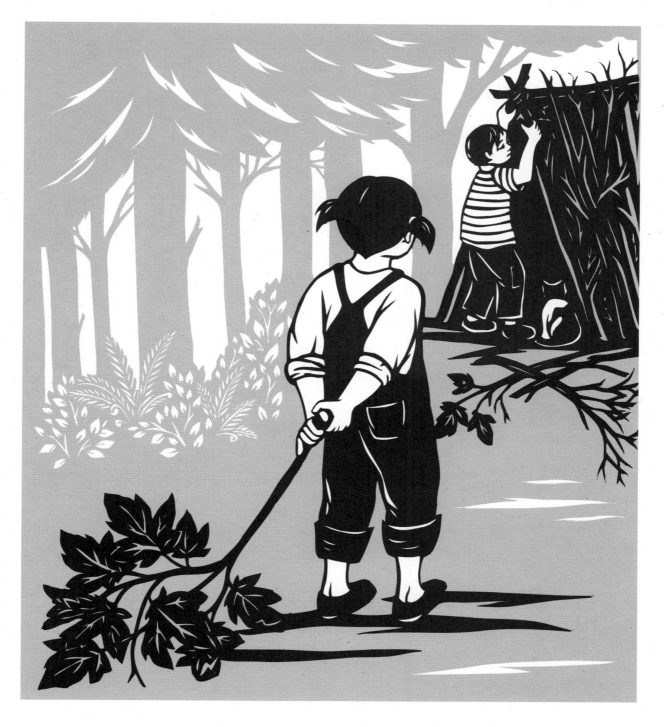

BUILD a FORT

PAUSE

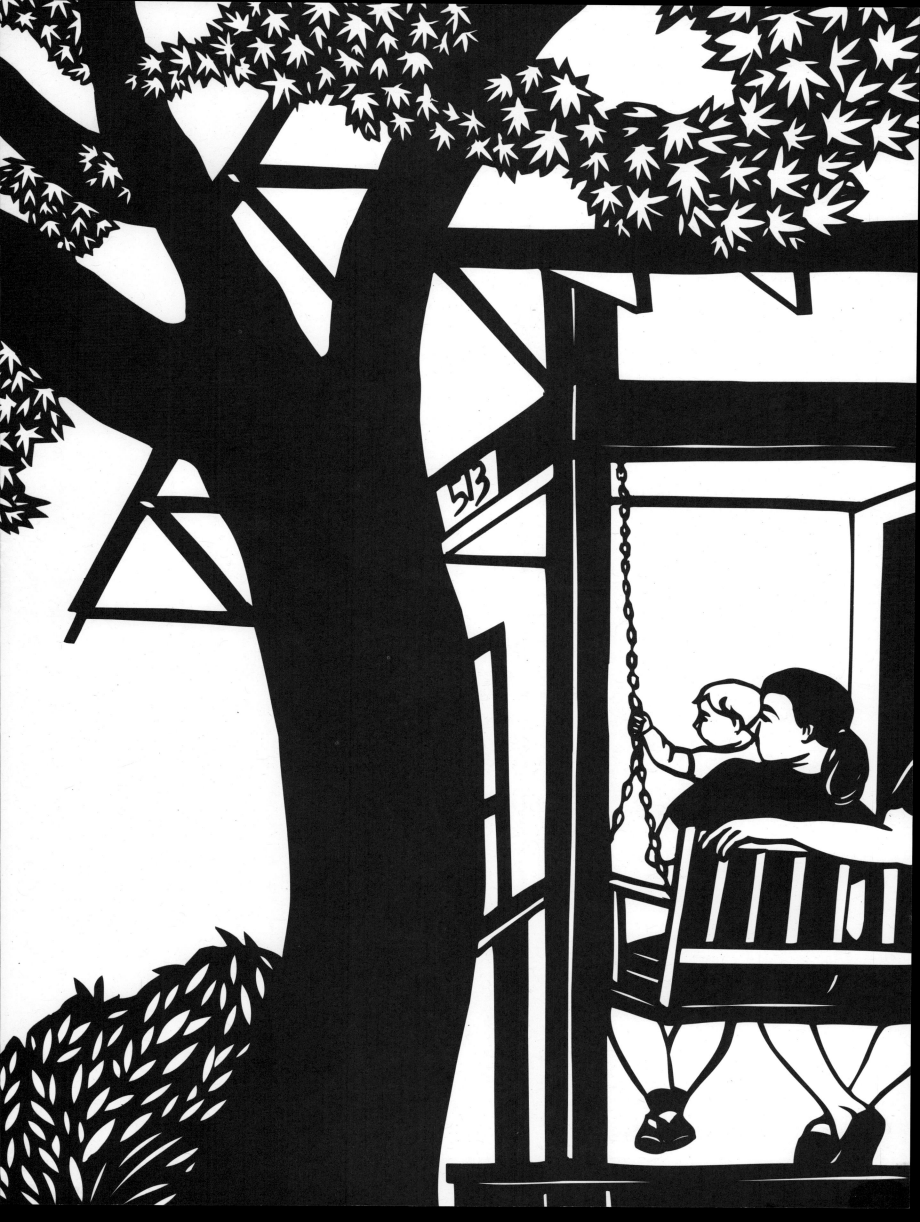

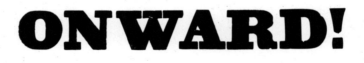

ONWARD!

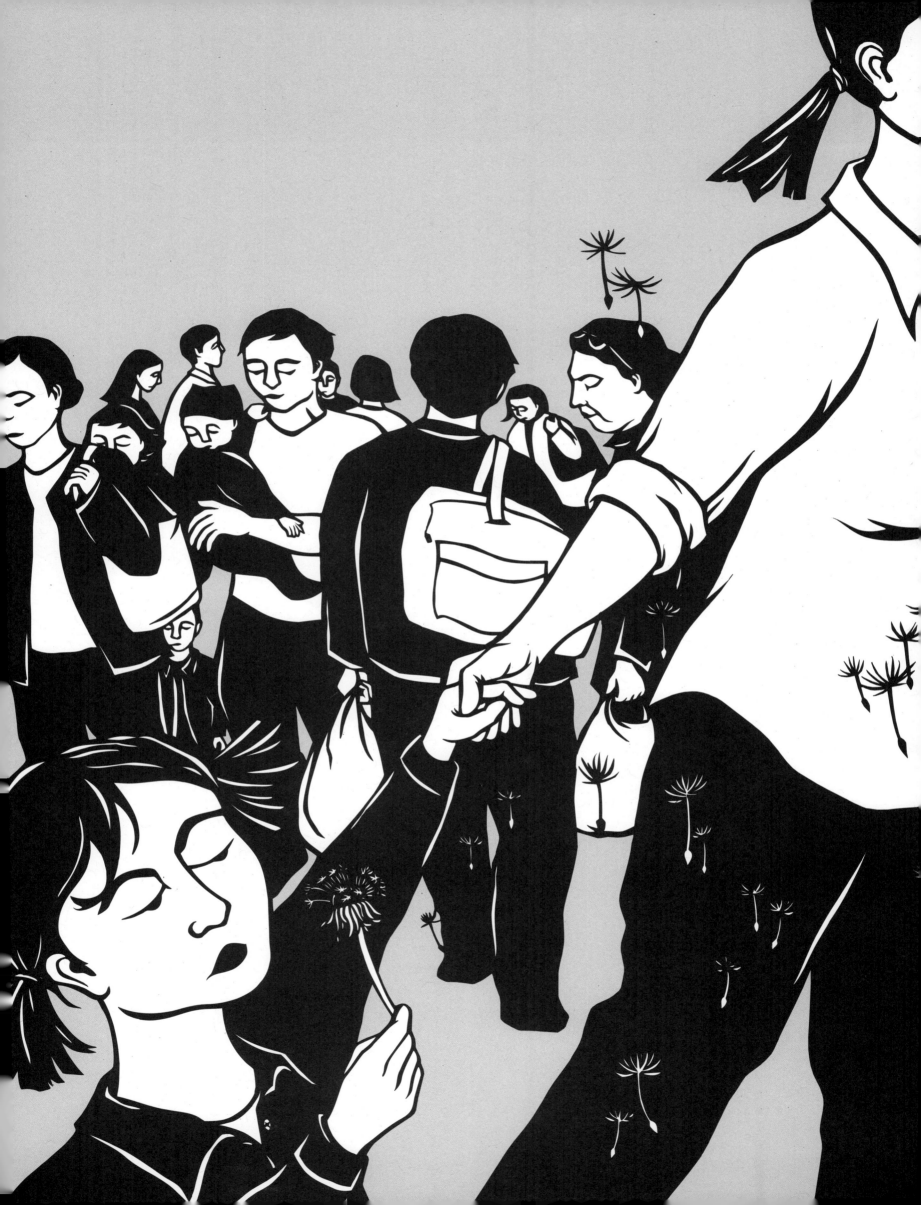

STRENGTHEN

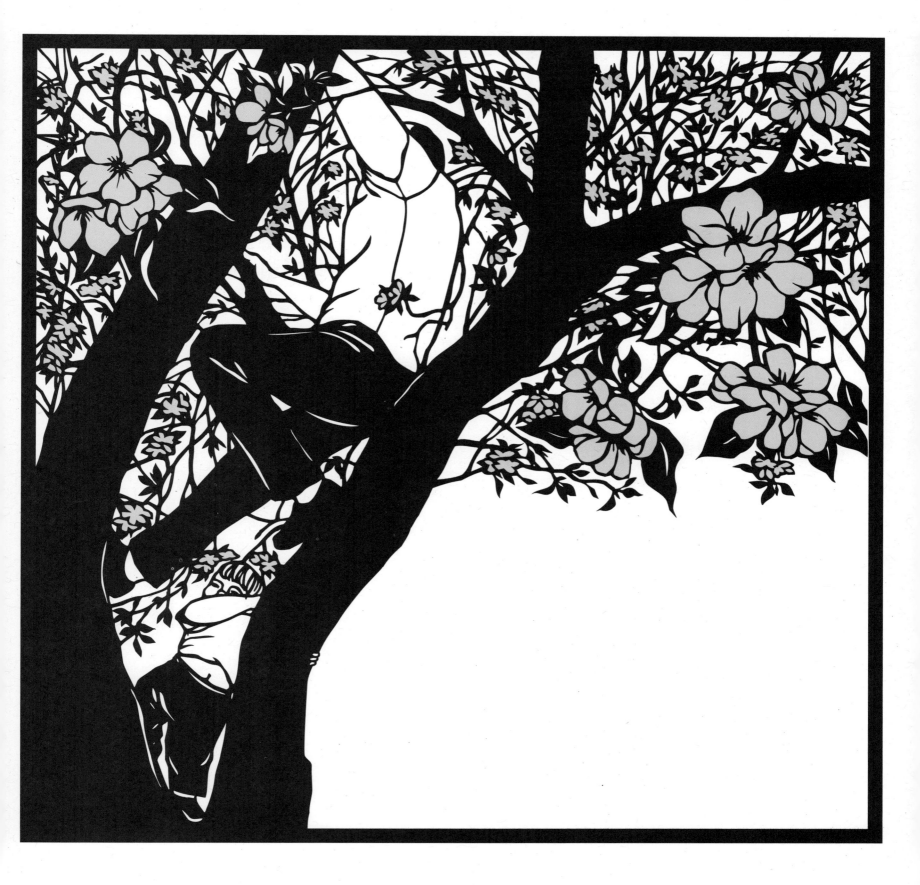

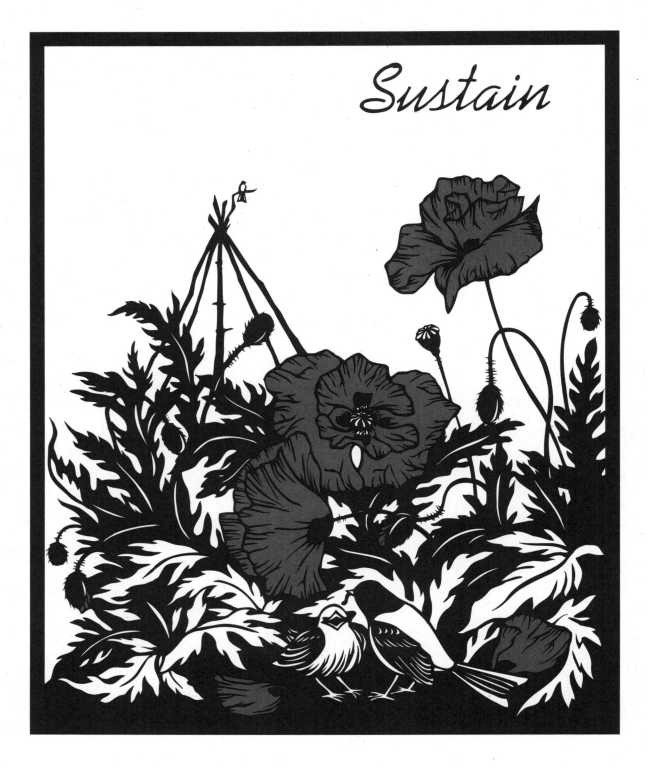

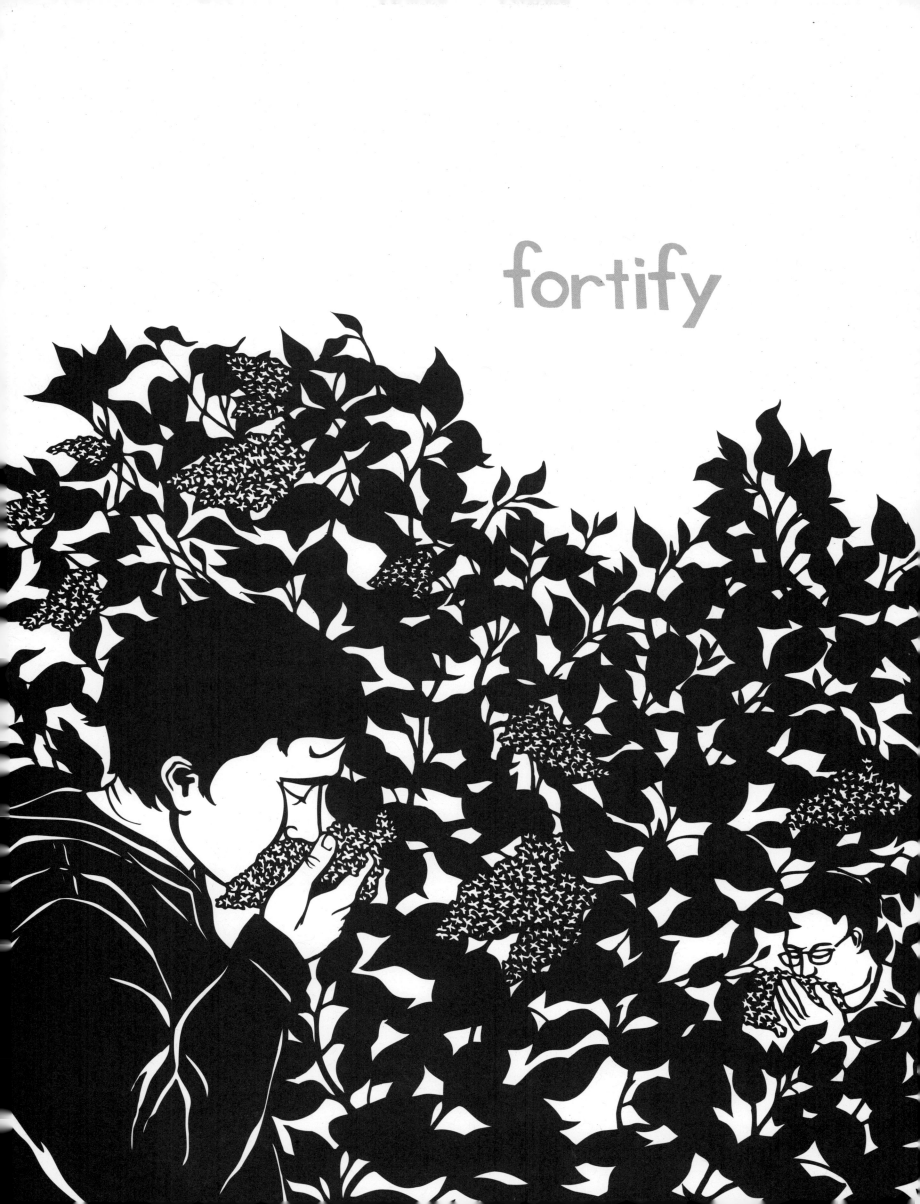

fortify

VOICE

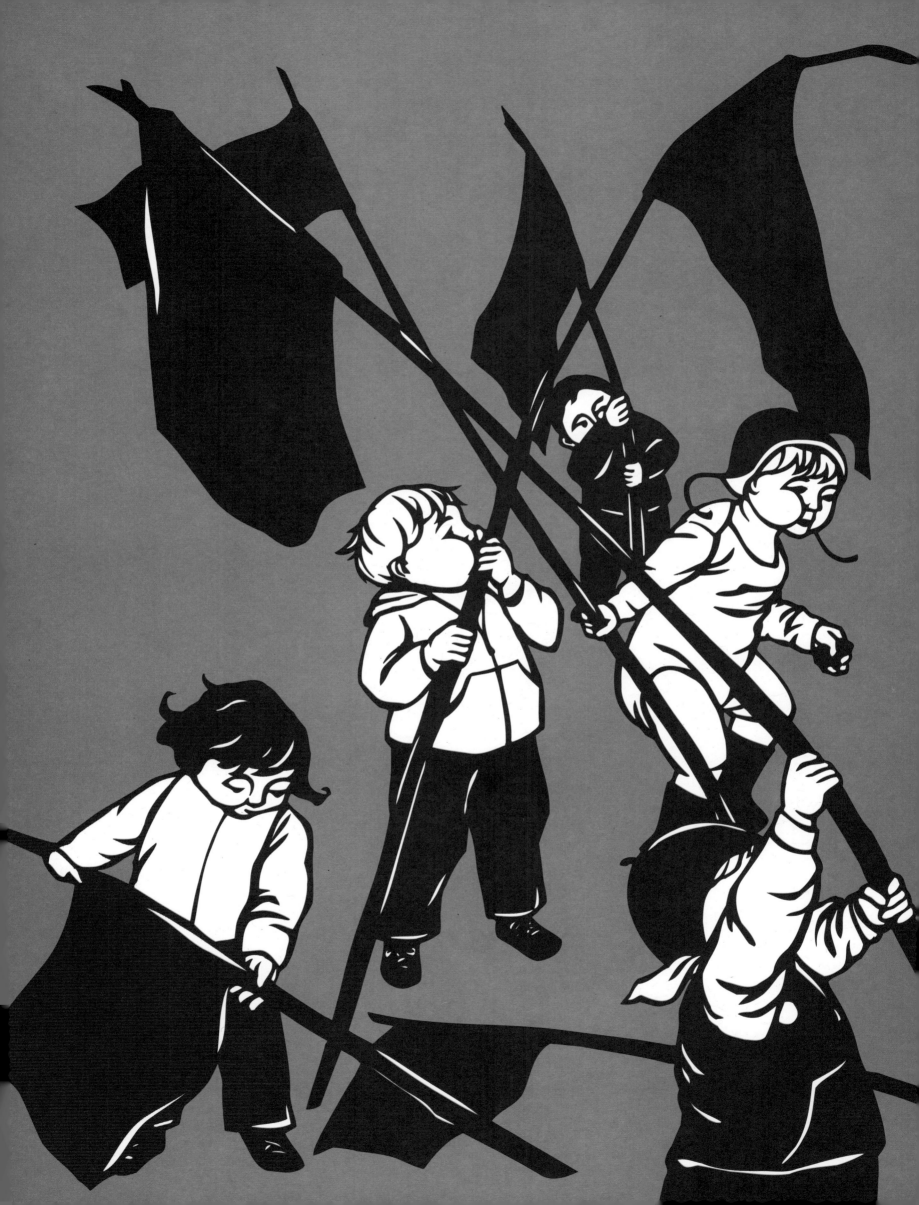

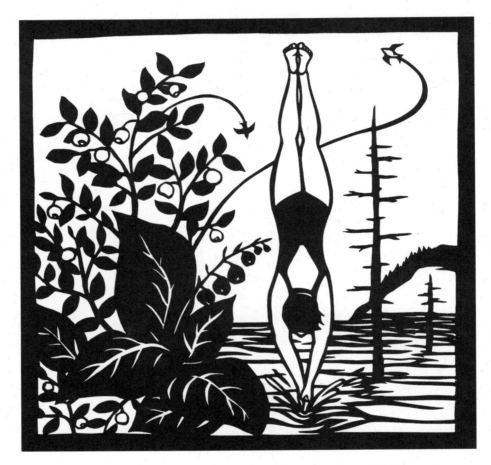

Now only time for the summer stillness
of huckleberry and salal.

SUMMER

We welcome the world. A bounty of light is received: strawberry, raspberry, blueberry, black. Fruits fill our buckets. Hands reach in, though not always our own, and the living made is shared. Arms are thorn-cut and bleeding. Mosquitoes hover for more. We open our dry mouths like the baby birds who rasp and cry. Fruit juice drips sticky-sweet rinsed off with hose or cold-water lake, ocean, sound. We lie down on the face of the earth and the heat blurs molecular lines. We melt into the grass, just water to surrender, limp and ready for siesta. Fruit juices distill into nectar while we sleep. Vines grow, eclipse, and cover. Sunflowers topple from their heavy ripening seeds, each holding the last of the summer sun.

The outside becomes inside. Tables are set in the shade of trees and we cook outside. We wander, hiking, picnicking, exploring the terrain. We search for the best watermelon, the most perfect nectarine. Summer is canned, frozen, preserved to remember.

It takes all day for the tide to fall and rise again, transferring the heat of rocky beach to the water's edge. We become otter, salmon, seal at night. Phosphorescence sparkles our bodies with pixie light. We stand up and become the starry night sky. New constellations are named and then we fall back into the waves again to create more universes. Eventually our heat transfers as well. Bones are chilled and the hot day is forgotten. We run chattering to our towels.

We try to hold on to the last days of bare arms and legs. Early caches of sunflower seeds stored by eager squirrels sprout a leggy forest hoping for just a little bit more. Just a wee bit more. Don't go. We only have sixty-four? Eighty-seven? Ninety-four summers if we are lucky. We hold on and take the last quick swim just to say that we did.

INCUBATE

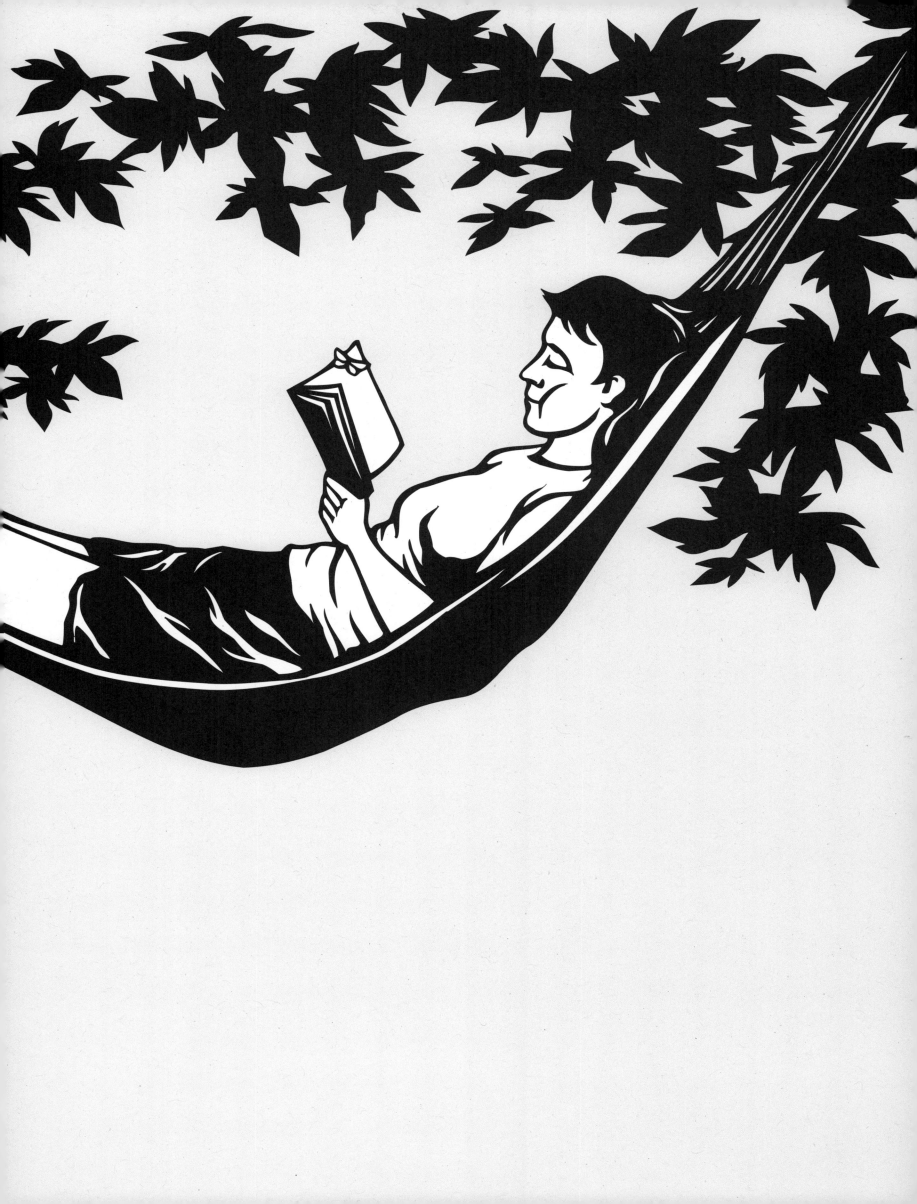

RECONCILE

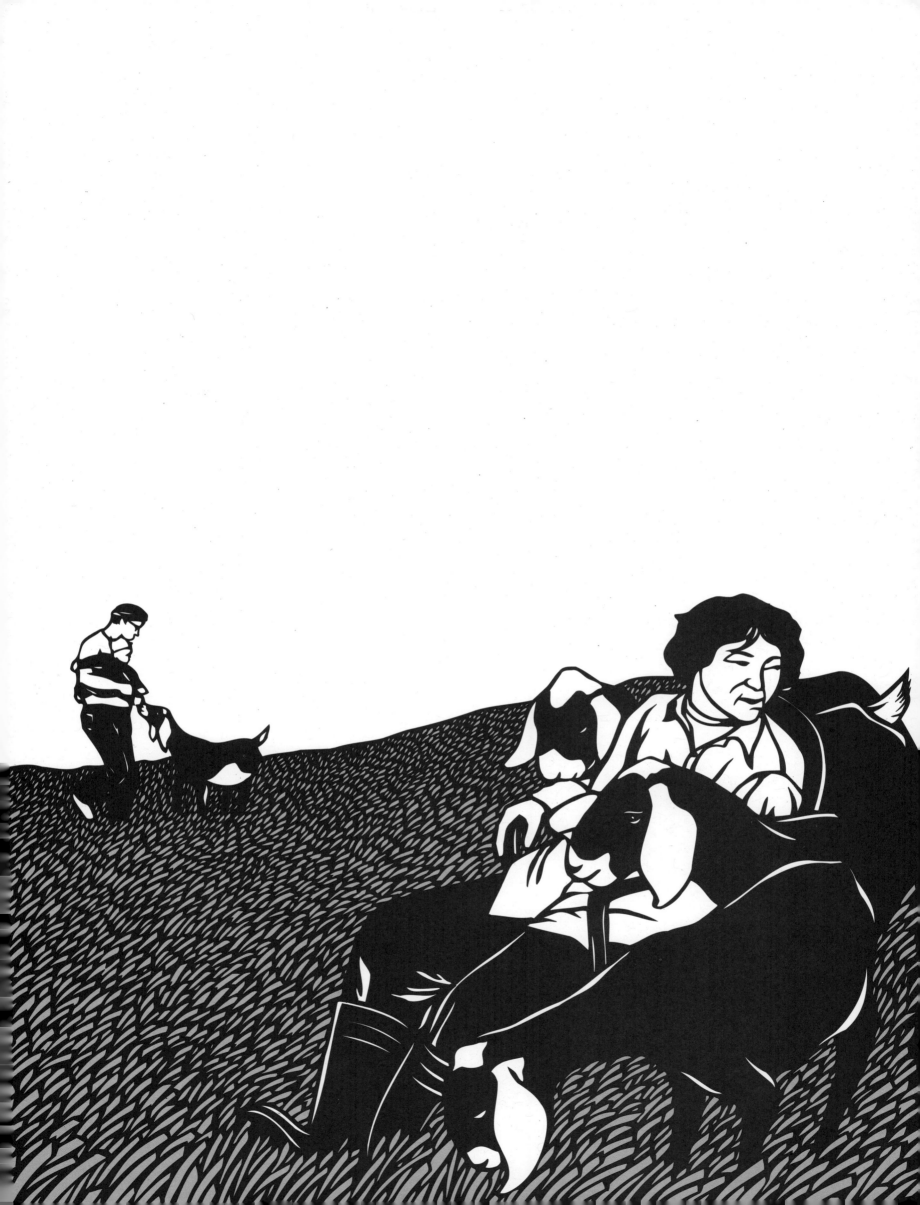

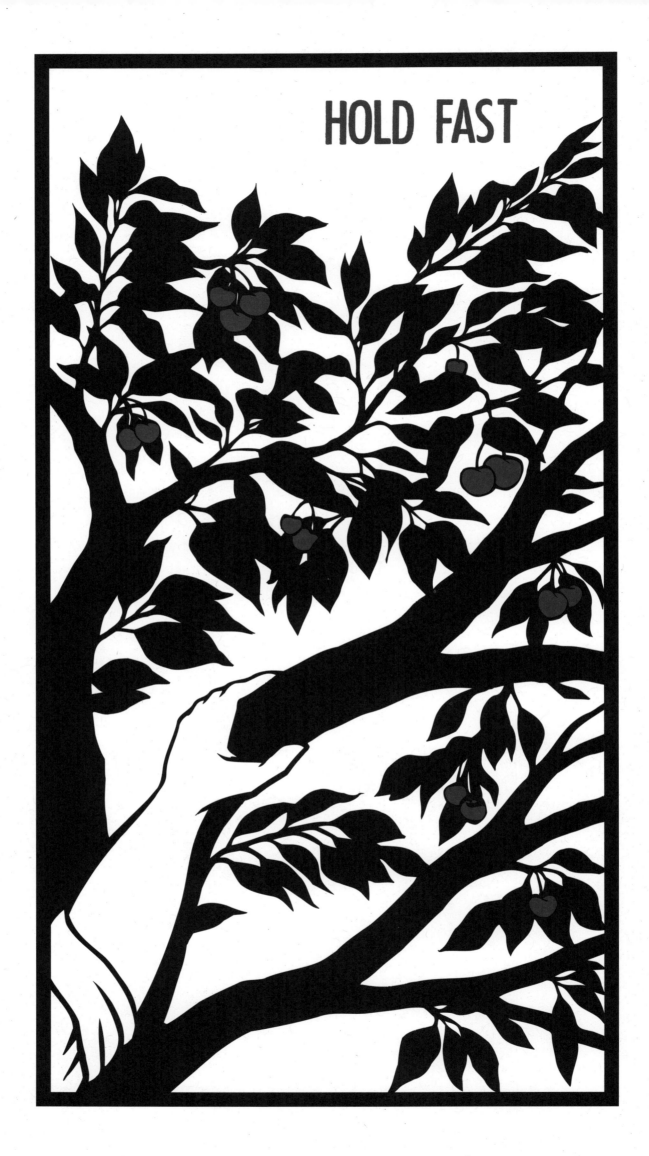

process

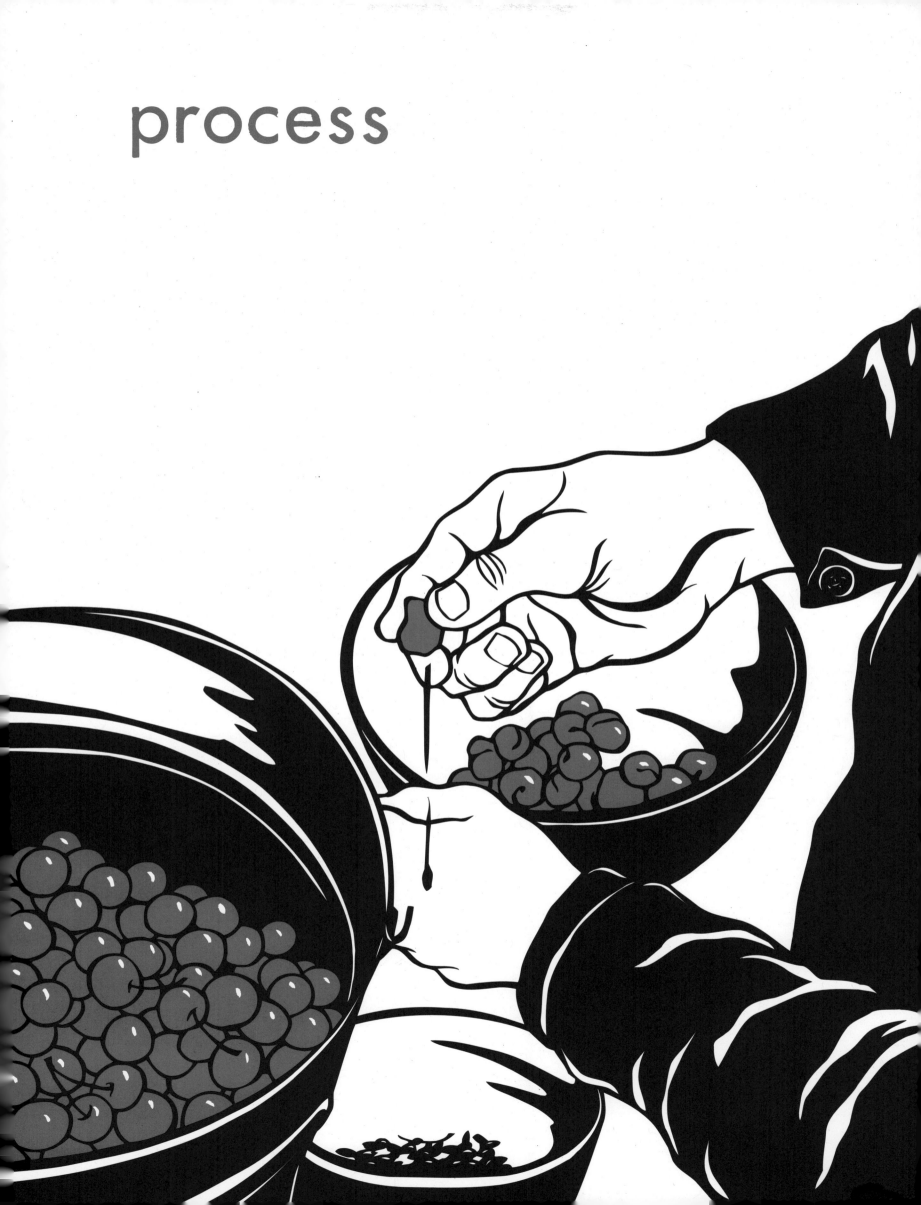

RESPOND

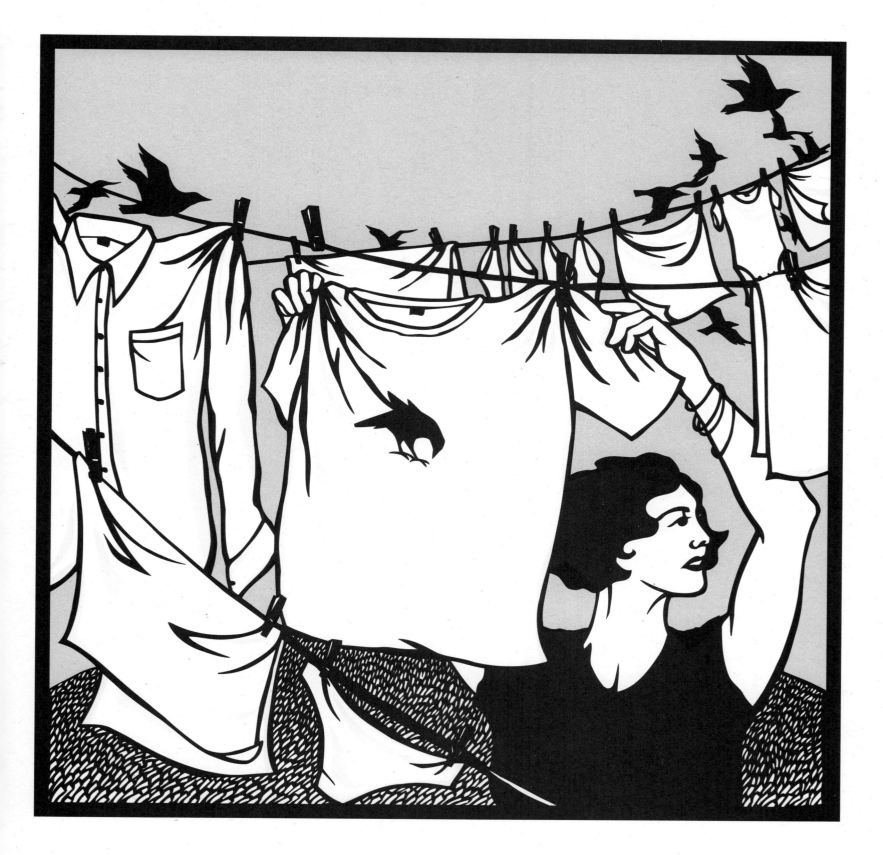

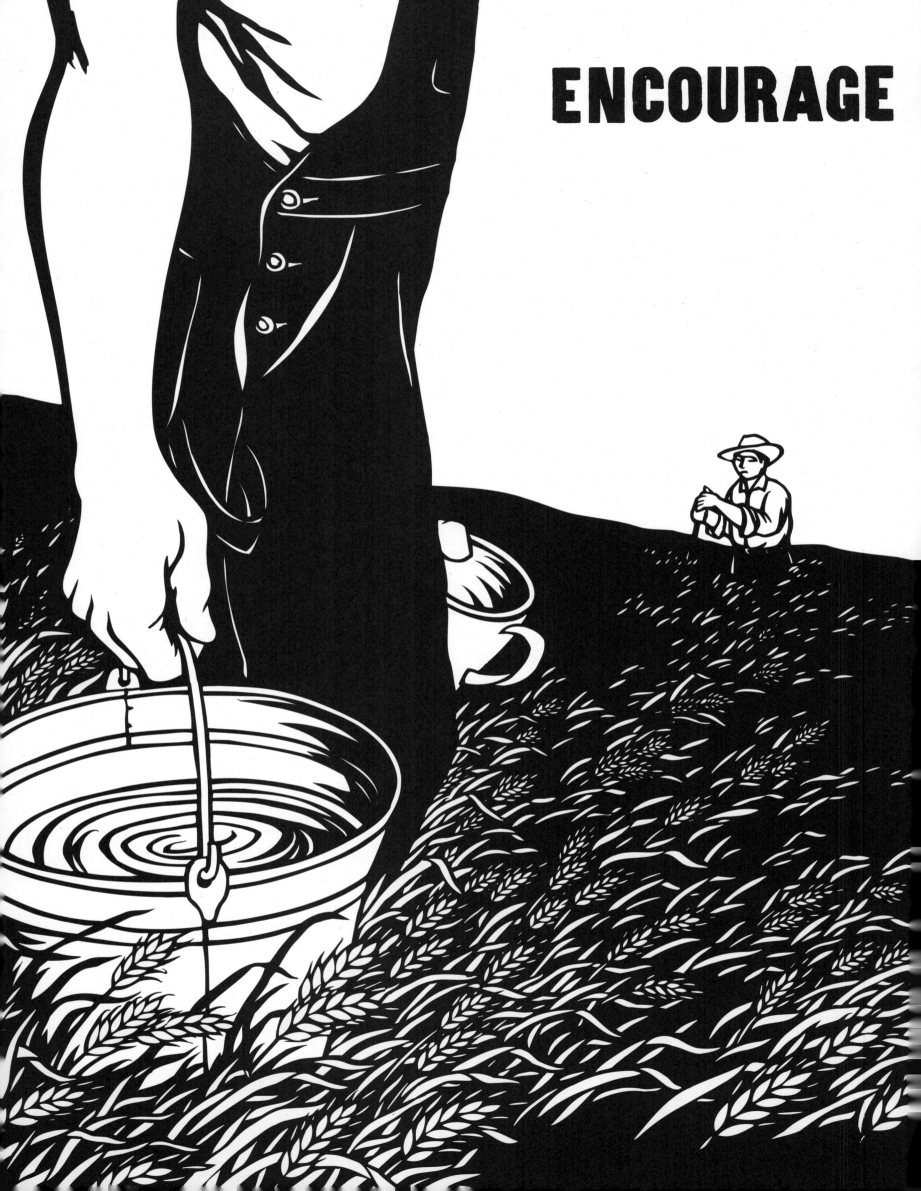

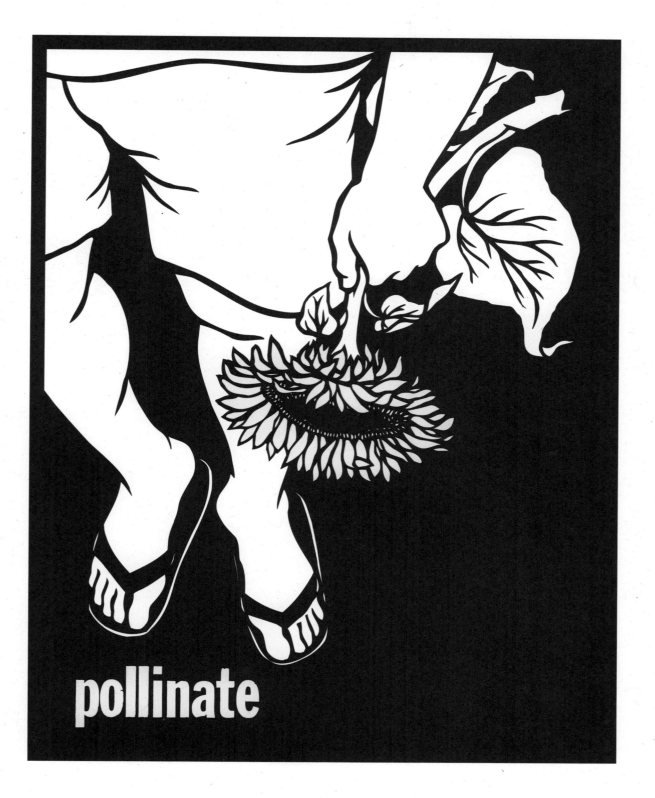

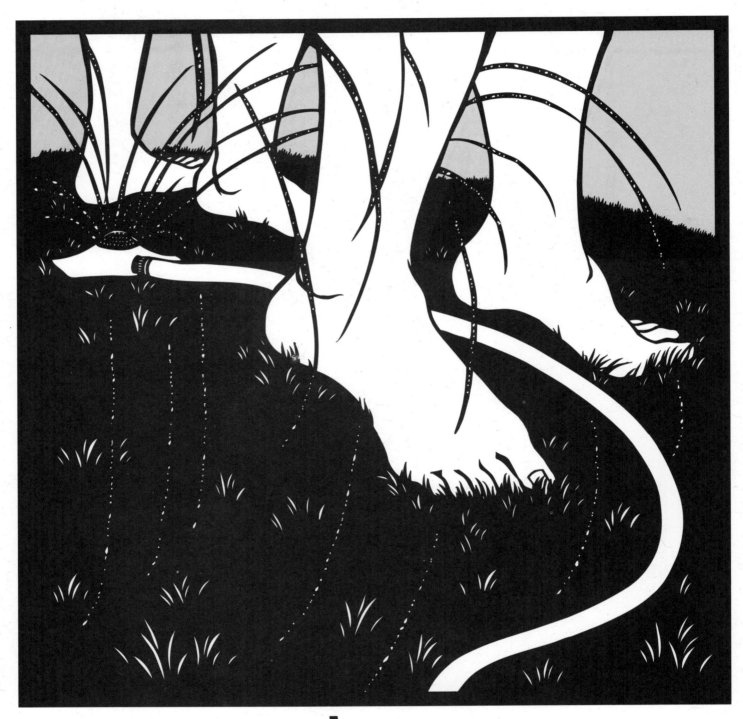

welcome

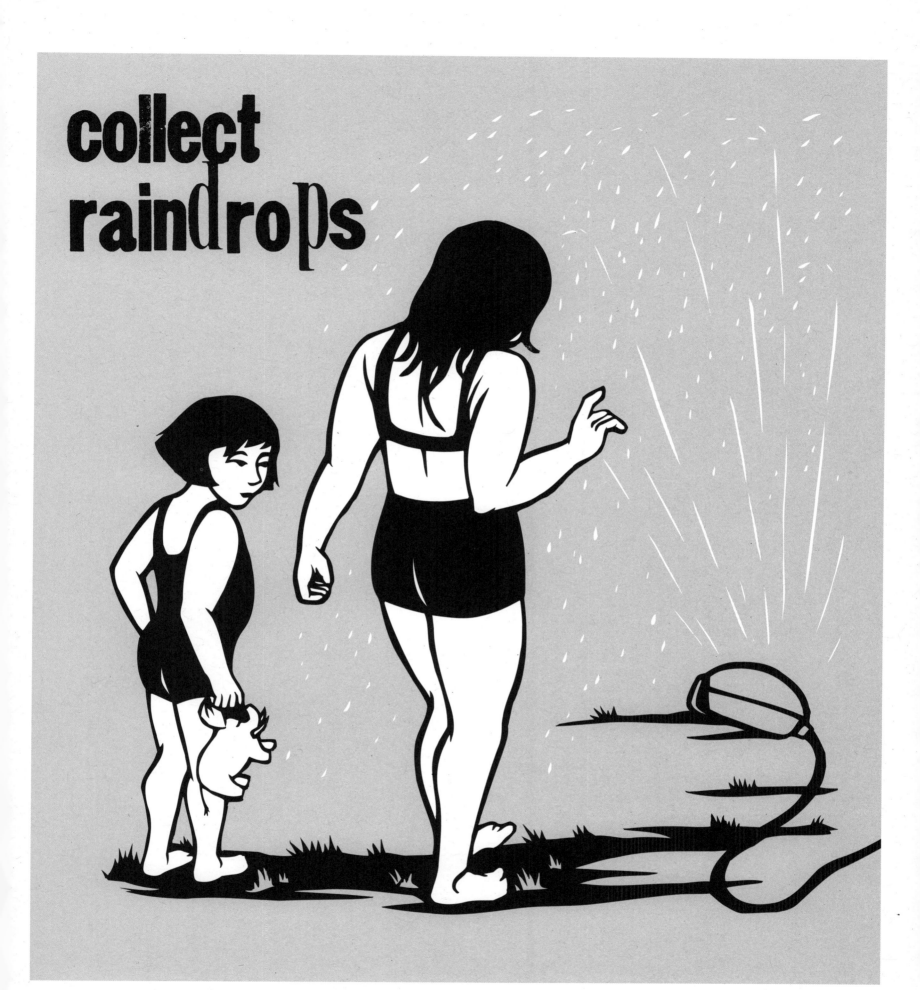

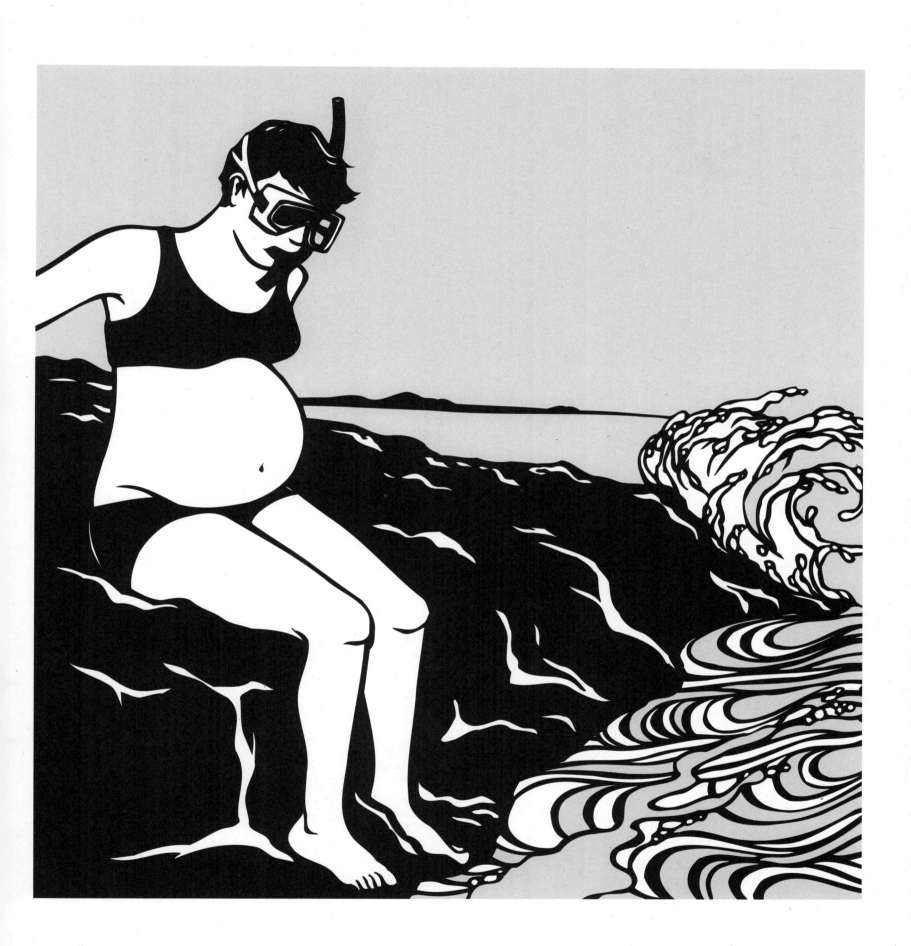

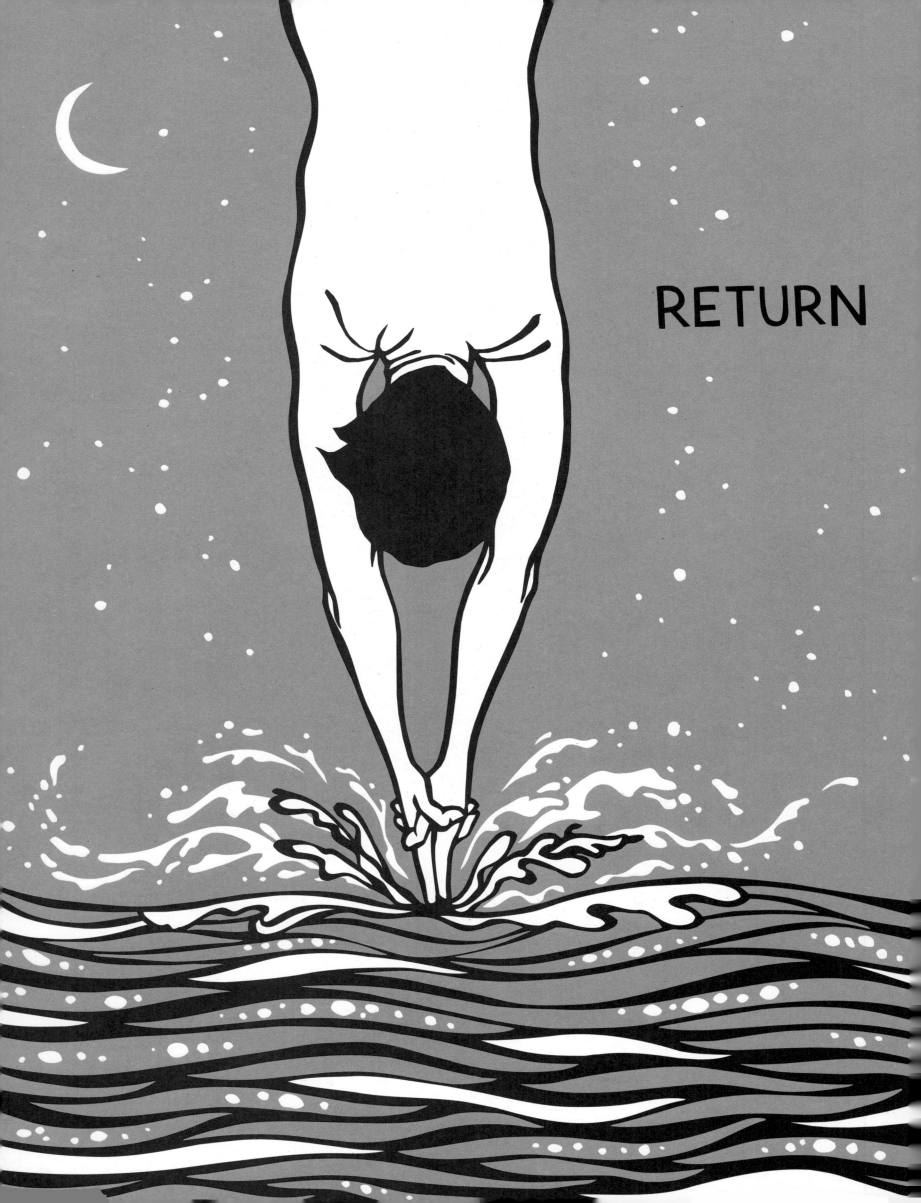

RETURN

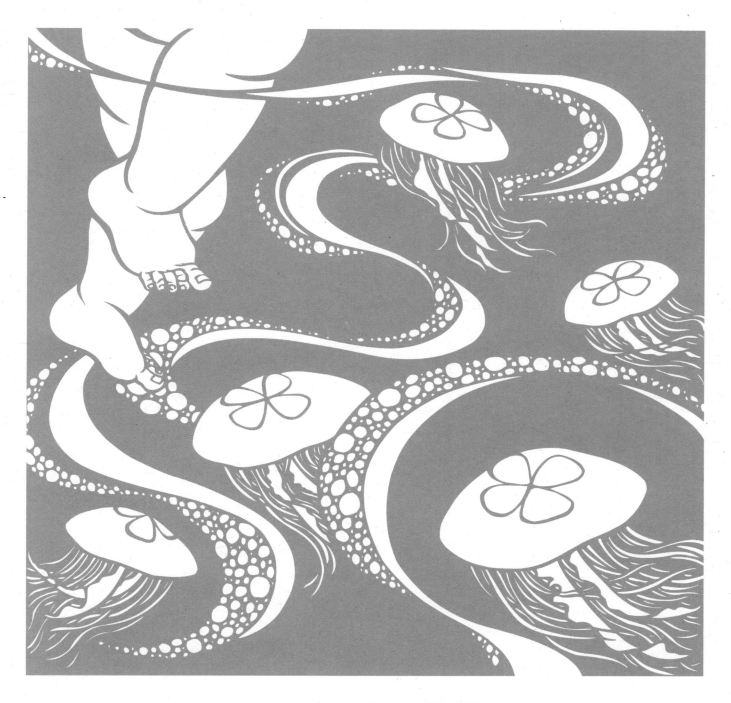

NAVIGATE

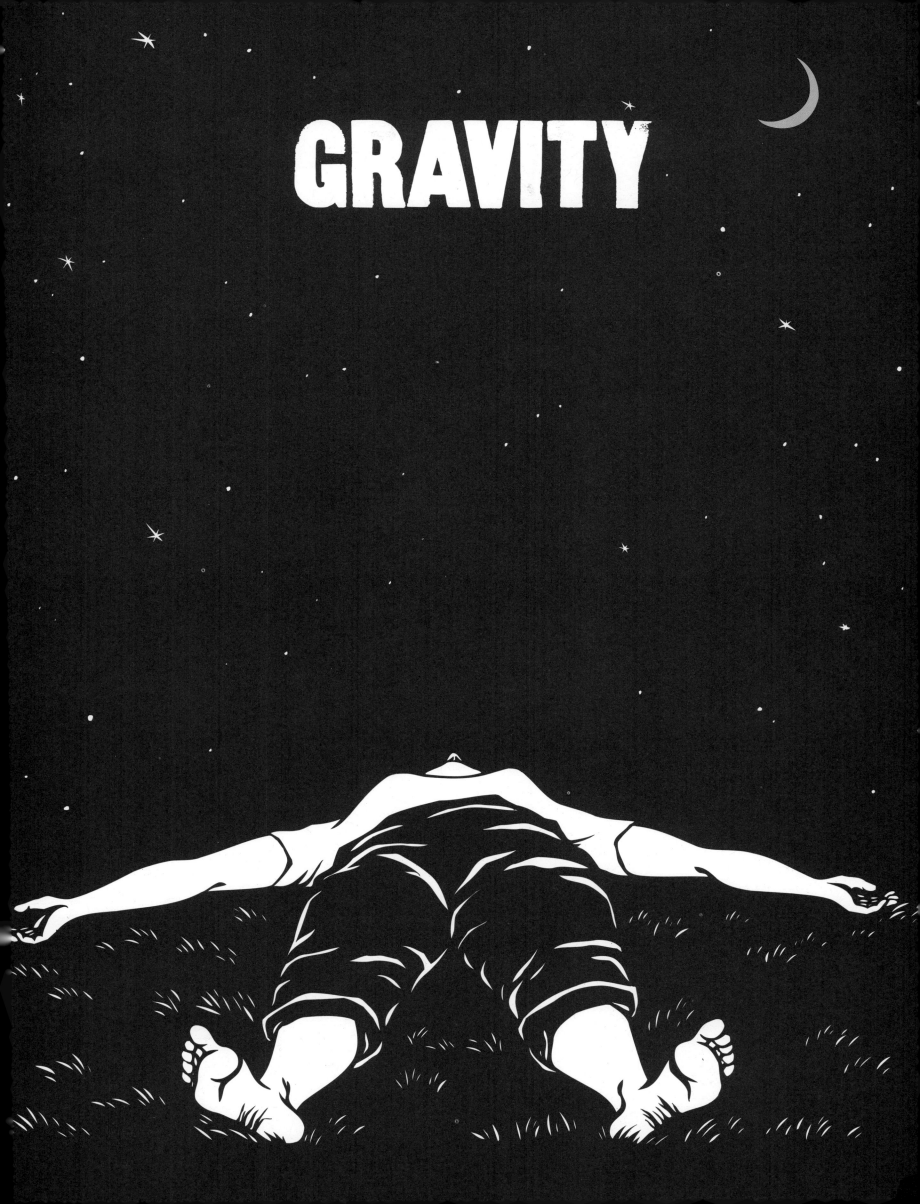

SURRENDER

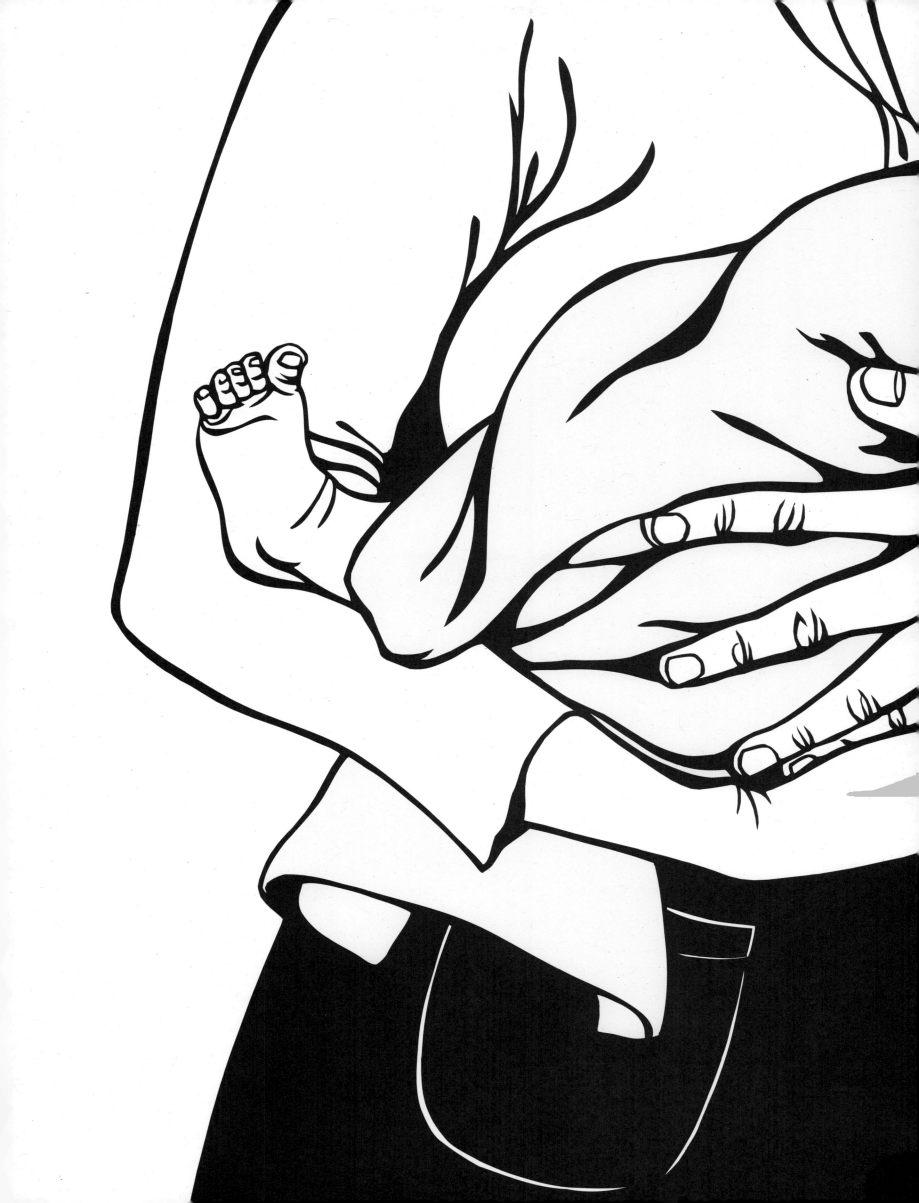

BREATHE

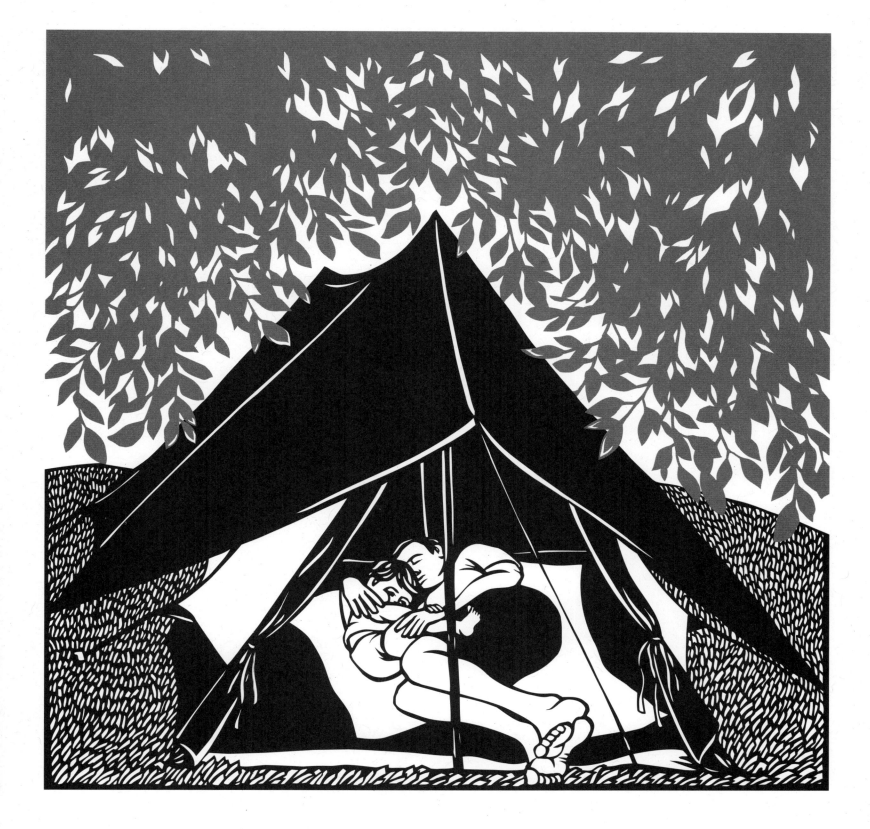

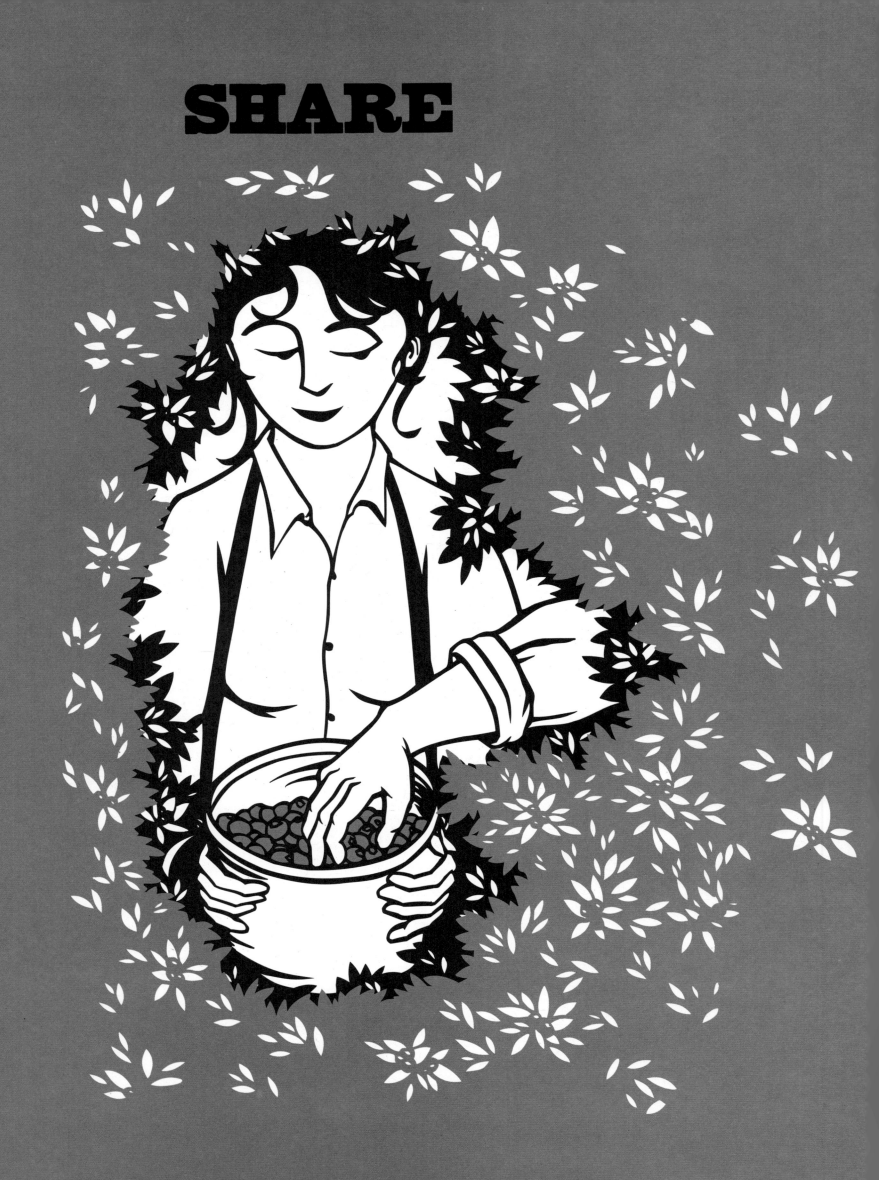

SHARE

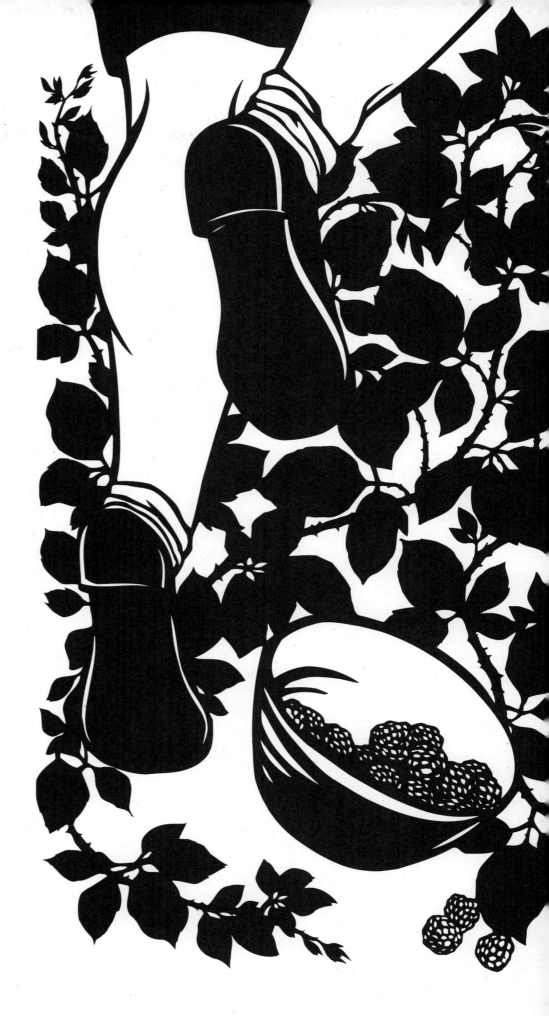

DON'T WAIT

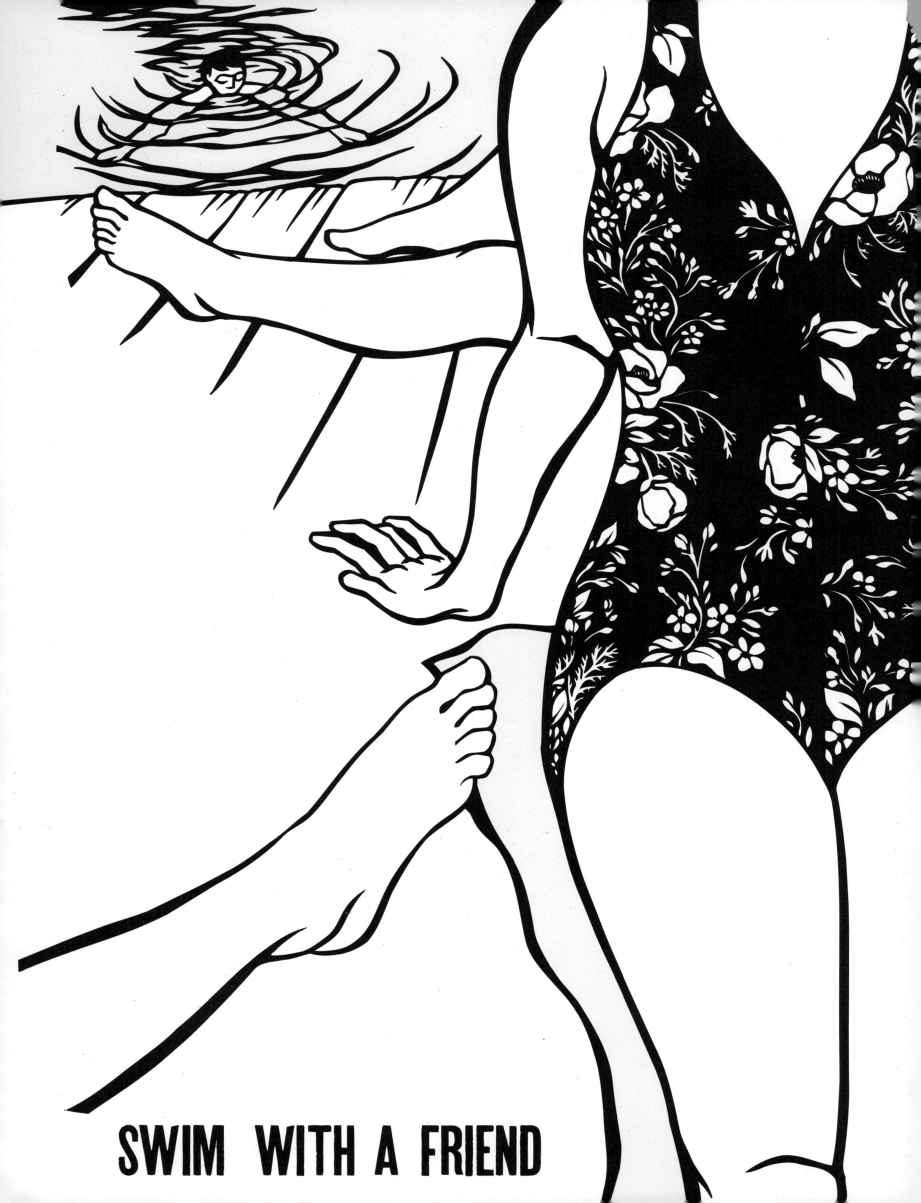

SWIM WITH A FRIEND

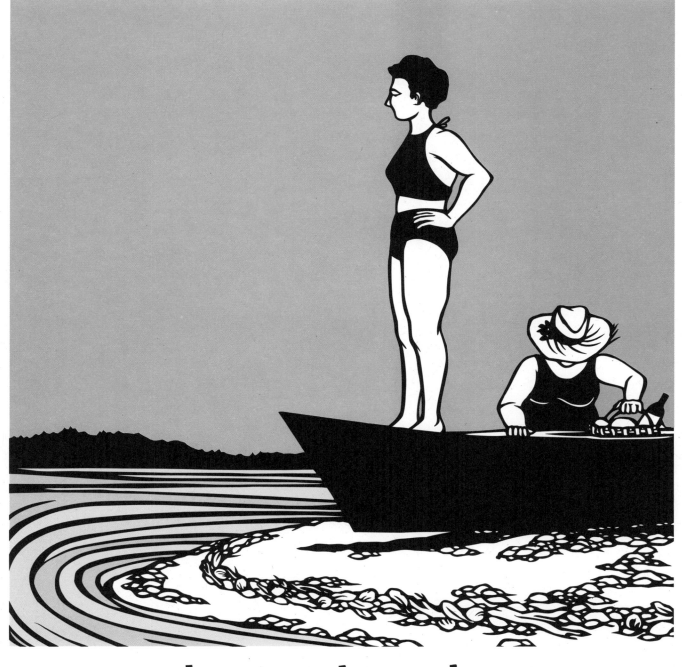

make it ship shape

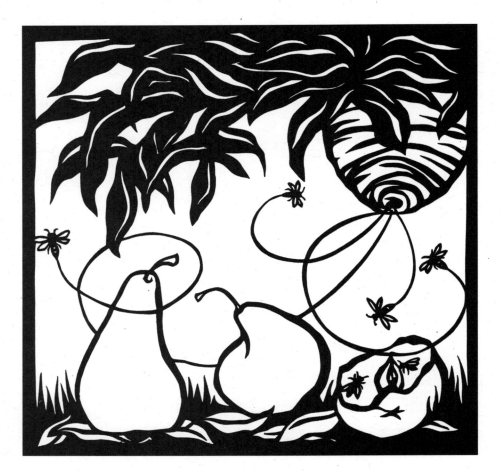

Summer is spent and decay begins.

FALL

Last chance, last peach. Last watermelon seed to spit. There is a quickness to everything now. First slippers, first sweater, first blankets wrapped around while reading. Need to learn how to survive the winter: get smart to escape famine and chill. The smell of rotten fruit is carried on the wind of buzzing wasps. The excess of summer is broken down by tiny jaws and mushroom rhizome. Gather all you can before the leaves leave and then gather these. Close the windows, turn on the stove, brew hot tea to hold. Winter is coming, winter dark, winter cold, winter hunger. Harvest the moon and be prepared.

A fat spider twirls up the last honeybee. Pause a moment and watch. Out in the garage a butterfly beats against the window wanting to be let free. The sun is shining, today. Make haste, butterfly. Find the withering flower, find a safe branch for your eggs to sleep through winter. Chickadees hang upside down and spill the sunflower's seed. Squirrels' brains grow to remember all their secrets. This year no buried nut will lay forgotten. We pile baskets full and keep the back door closed so the squirrels do not discover our riches. There is free protein, free energy, dropping from the skies. All you have to do is stop and pick it up. Stop one hustle and start another kind of dance. Scurry from tree to tree. Fill your pockets, shirttails, wheelbarrow. Ride around the block smelling for fallen fruit. Night comes too early. Houses glow with industry as all the food is inspected and stored away in mouths, in boxes, in baskets overflowing. Wipe your feet. Come inside. We have ten plum pies to eat tonight.

ATTEMPT

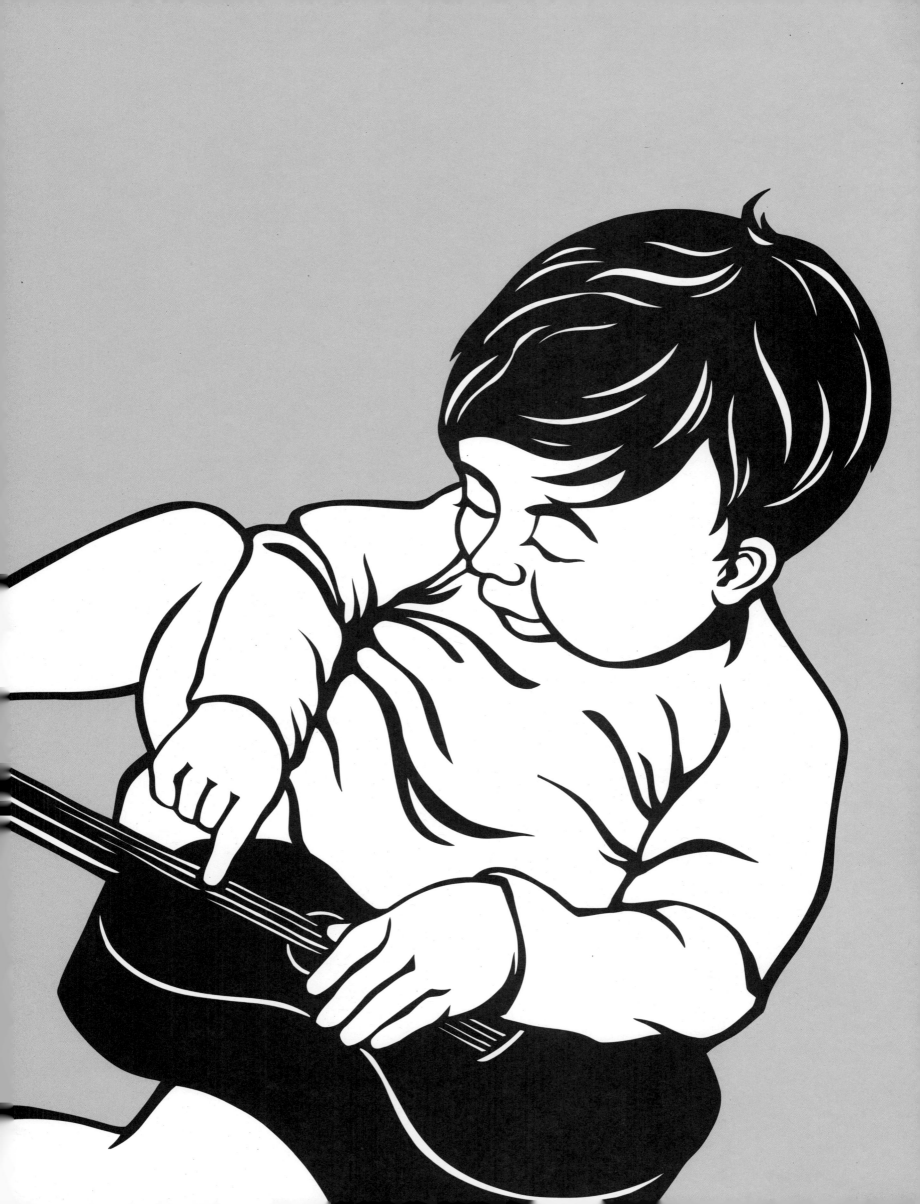

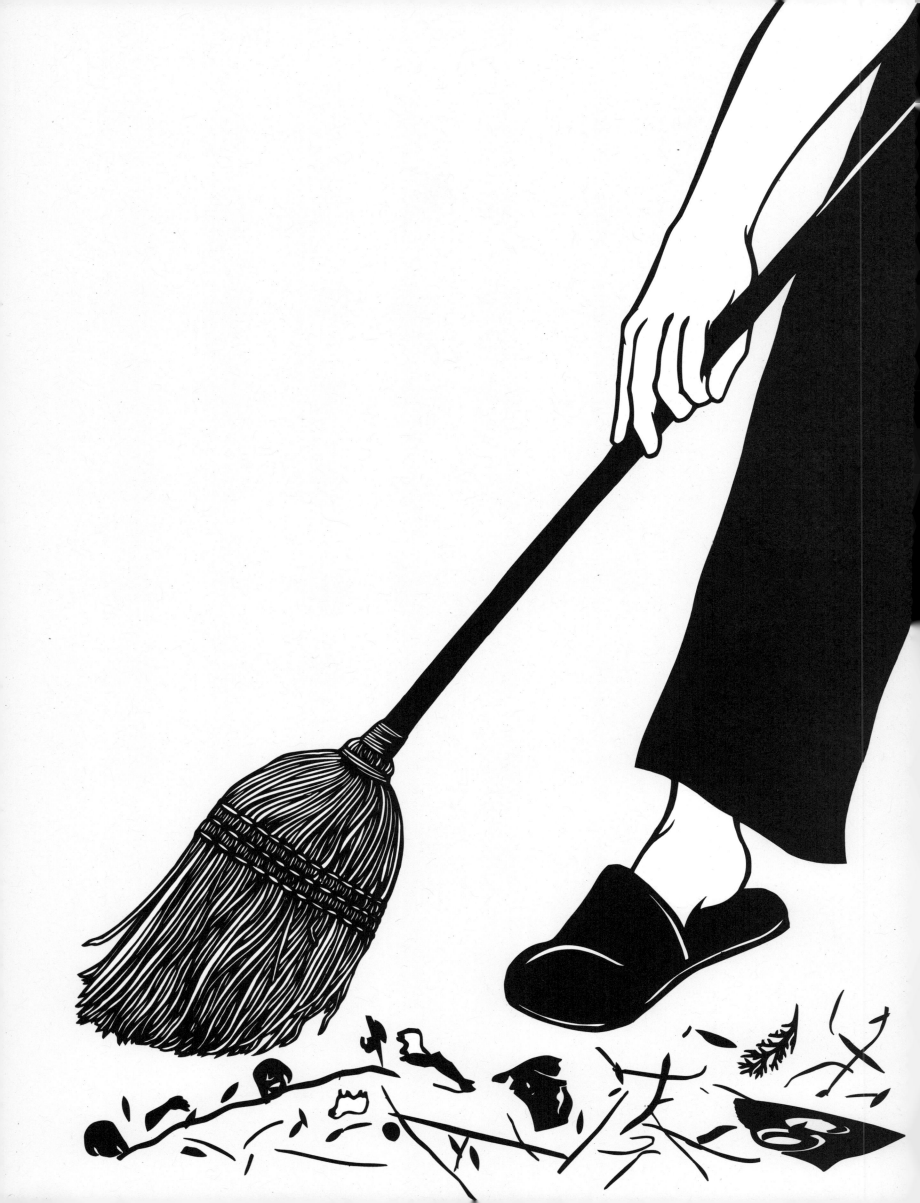

Make Mistakes

REMEMBER

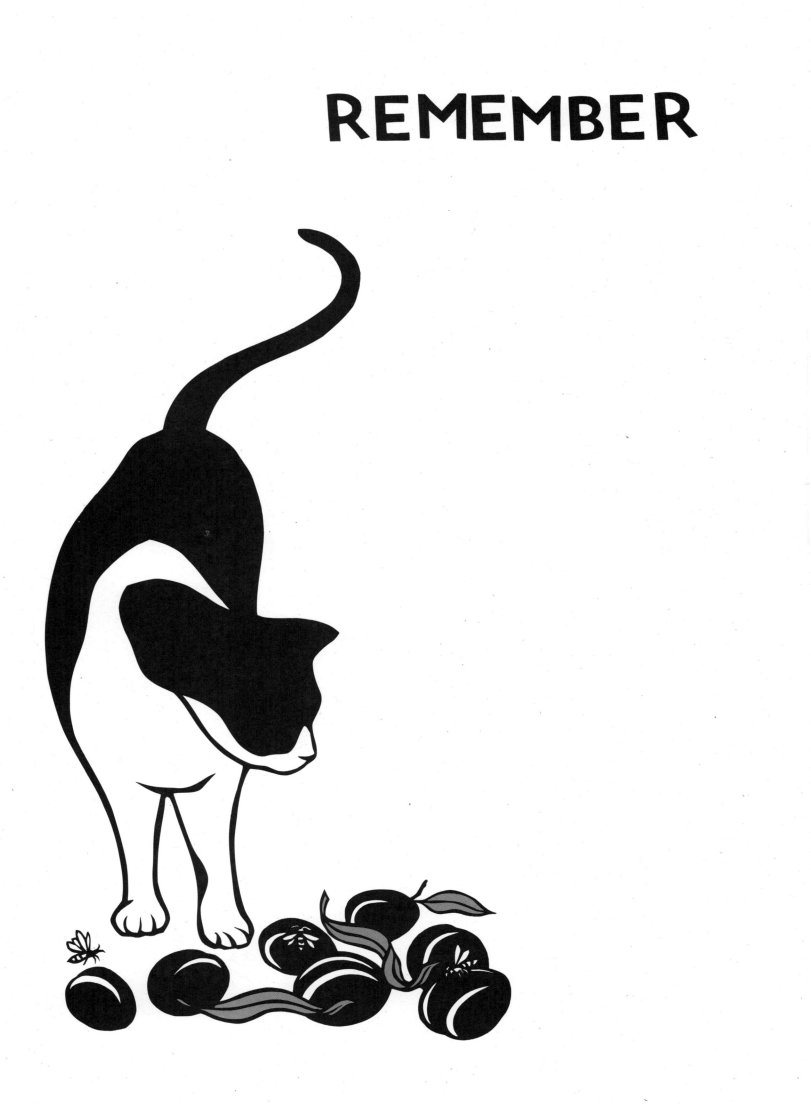

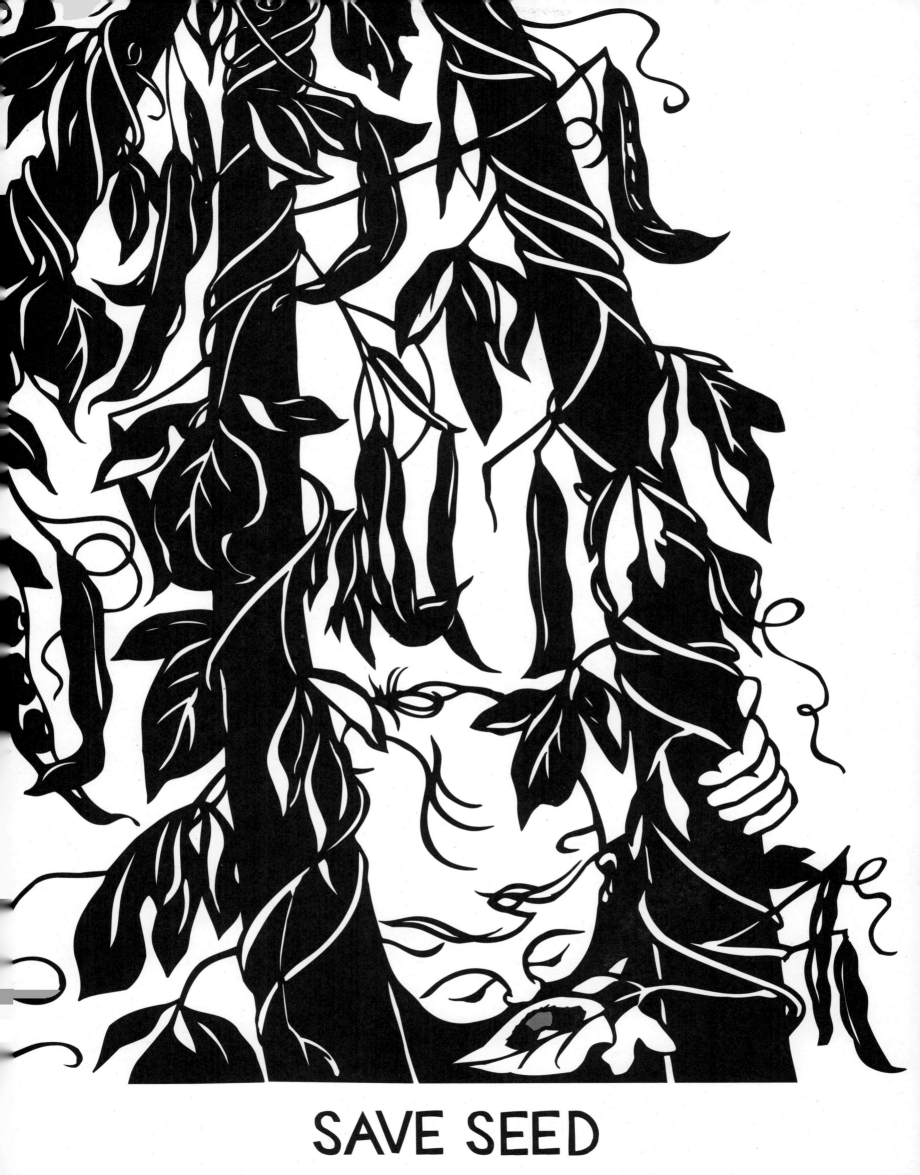

SAVE SEED

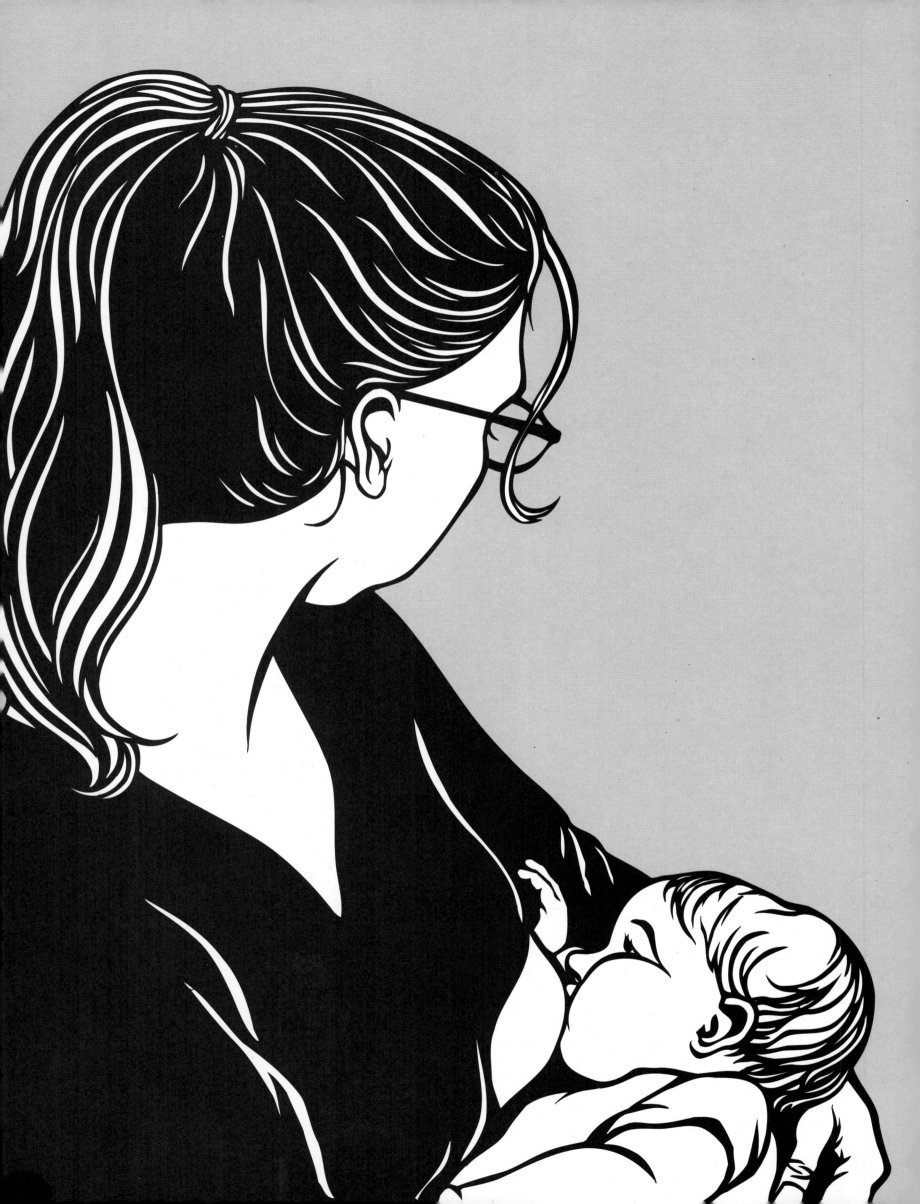

examine the food chain

realize true riches

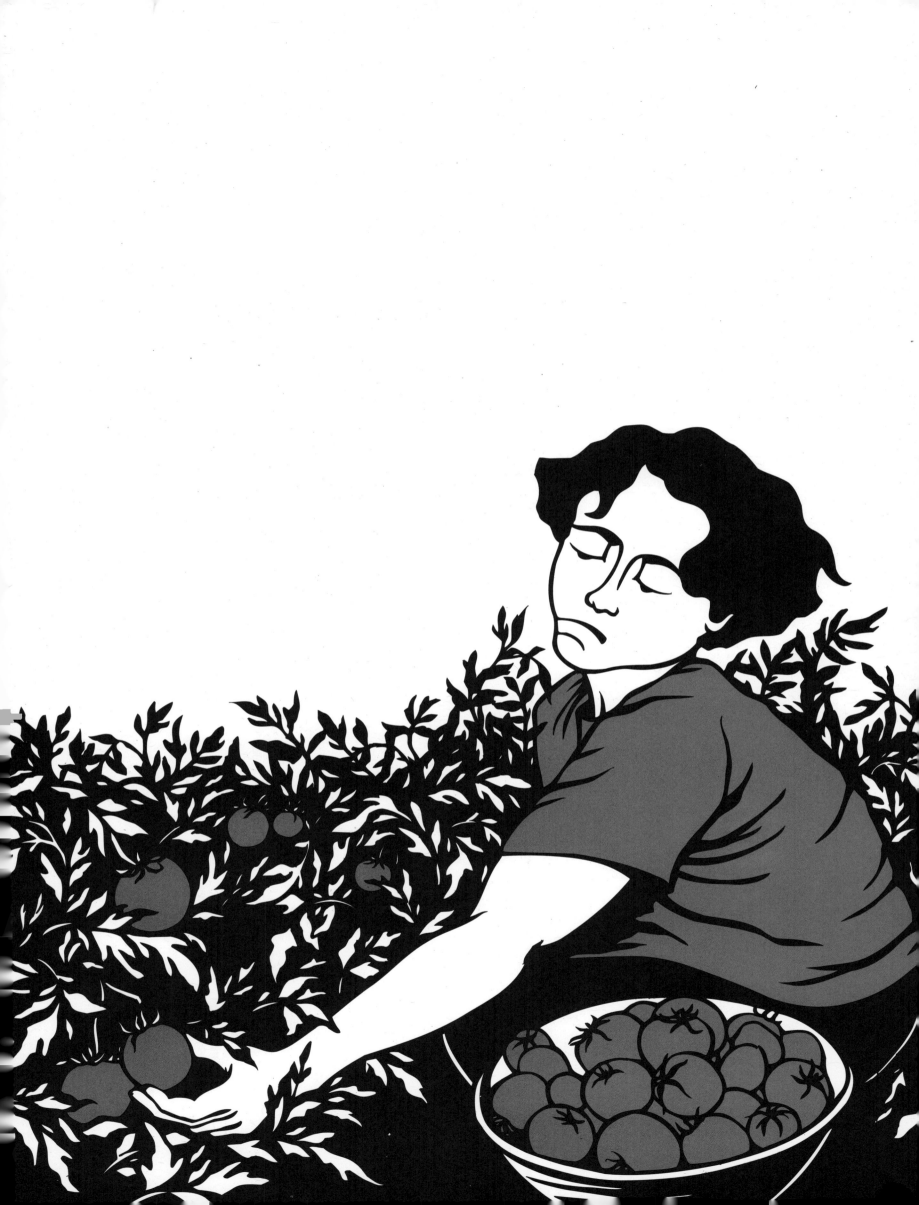

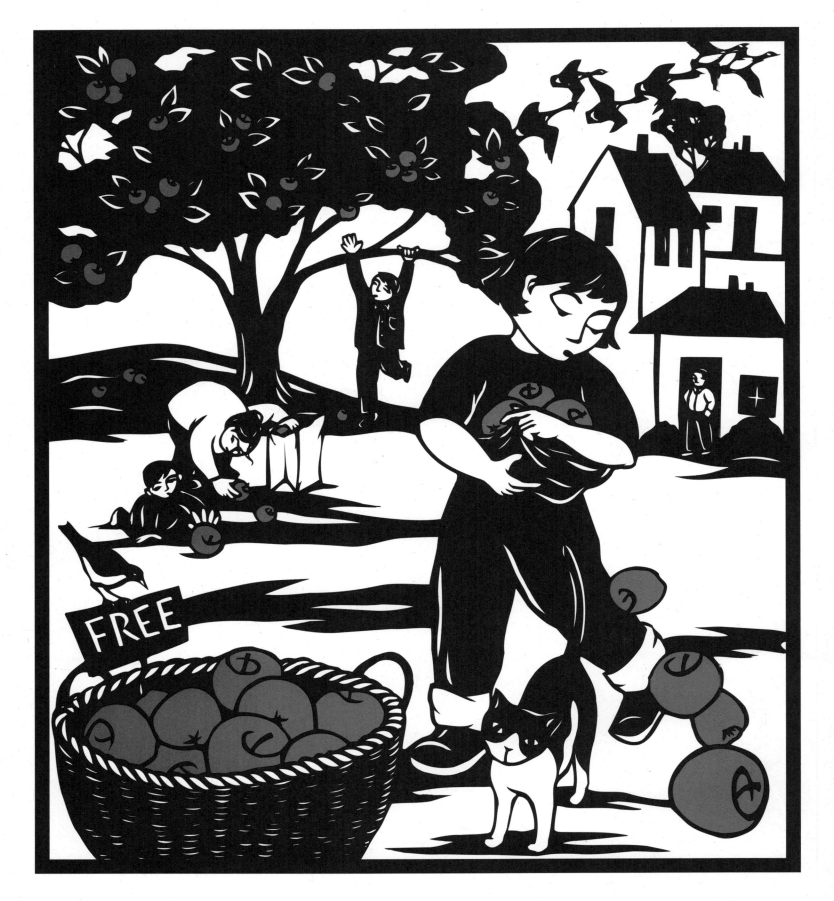

GROW FOOD FOR YOUR NEIGHBORHOOD

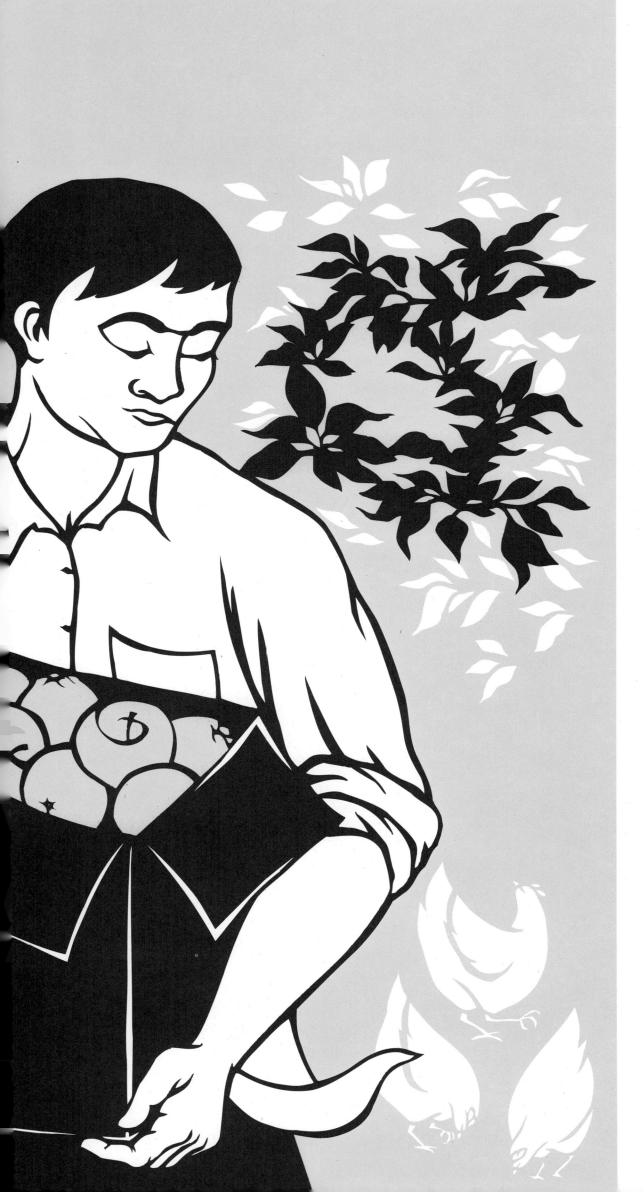

MAKE
APPLESAUCE

HUNT AND GATHER

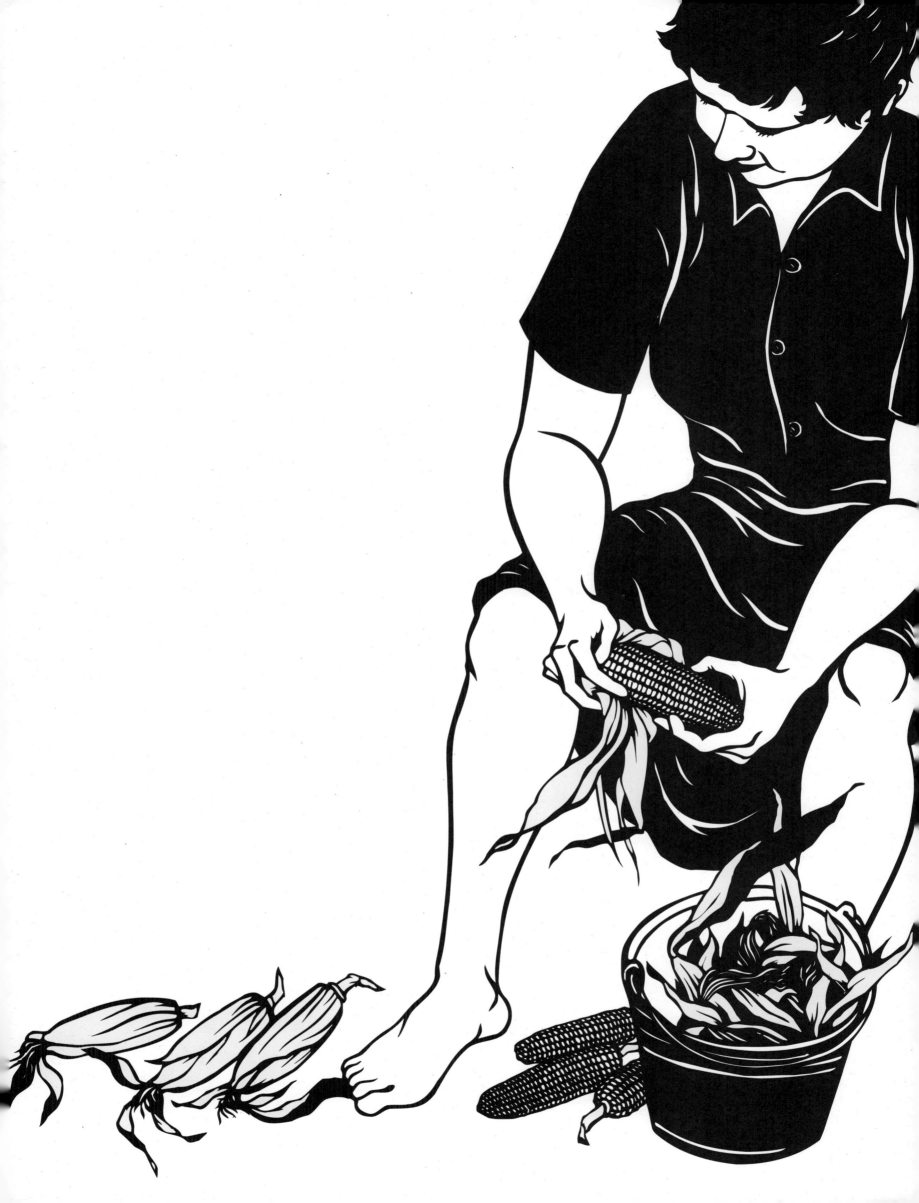

CONSERVE

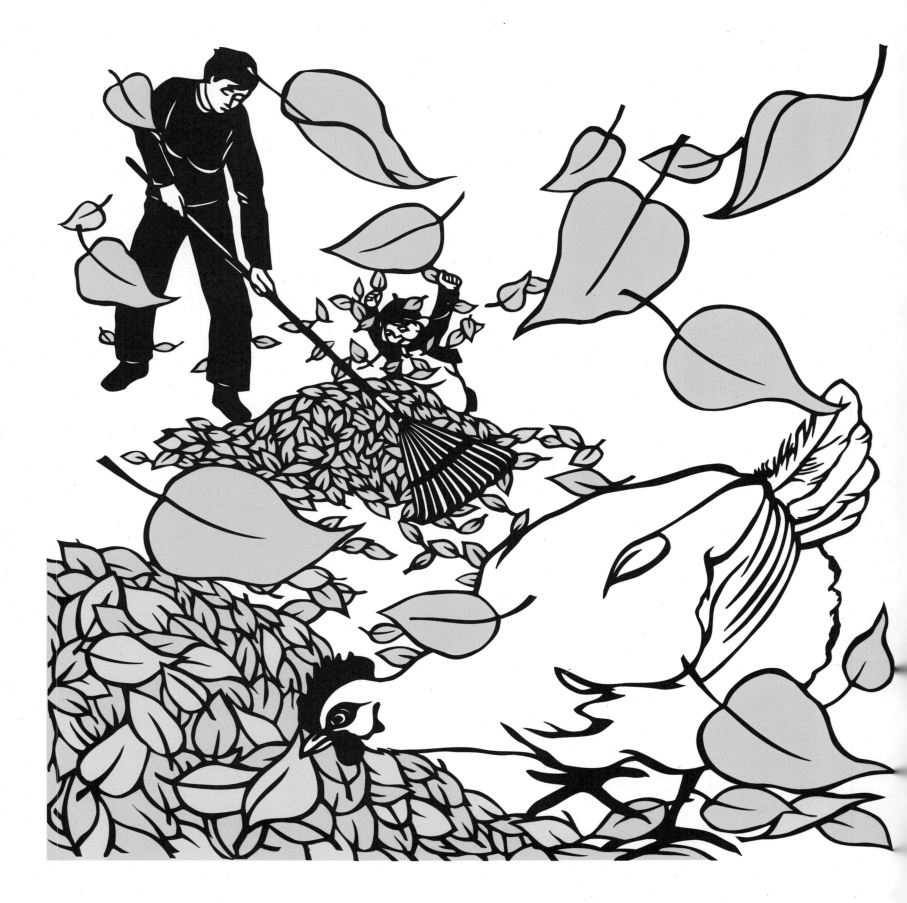

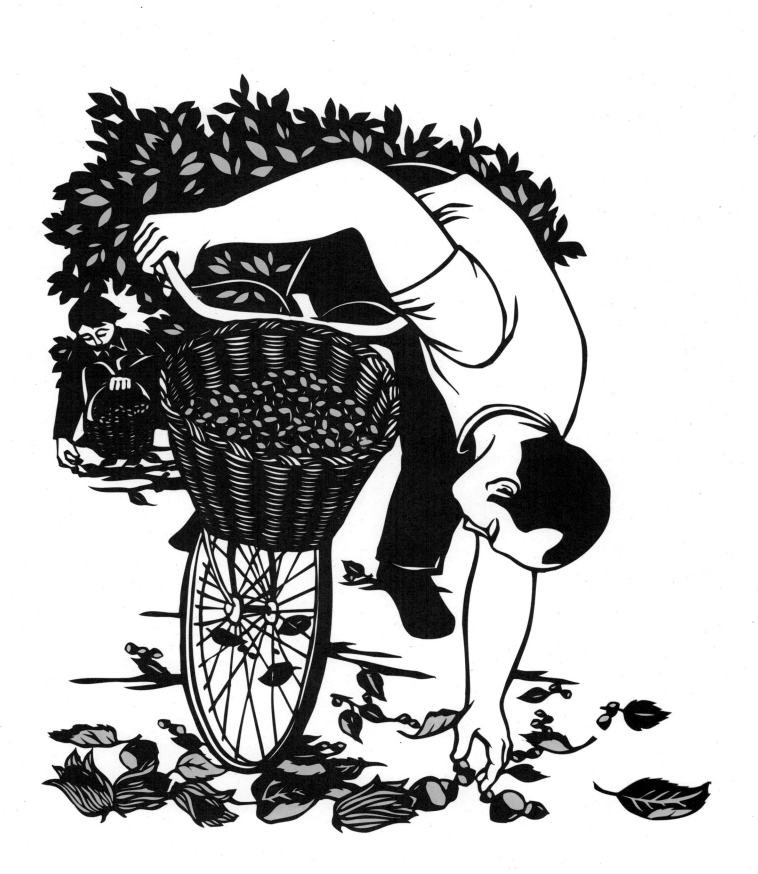

find it for free

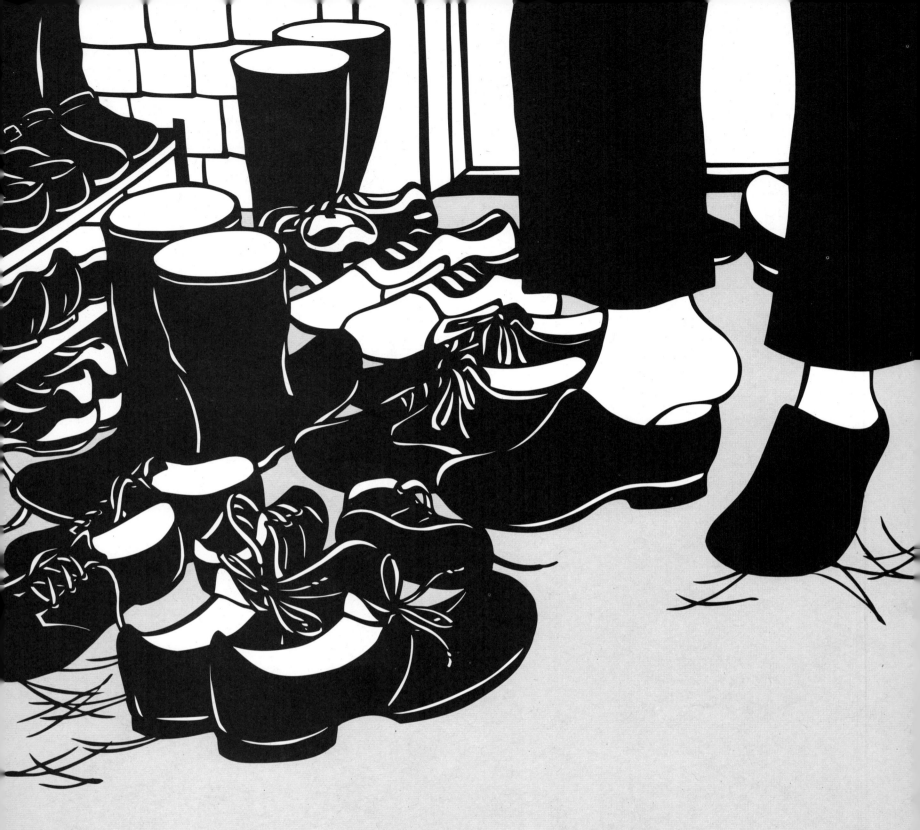

CONGREGATE

create your
own economy

FEAST

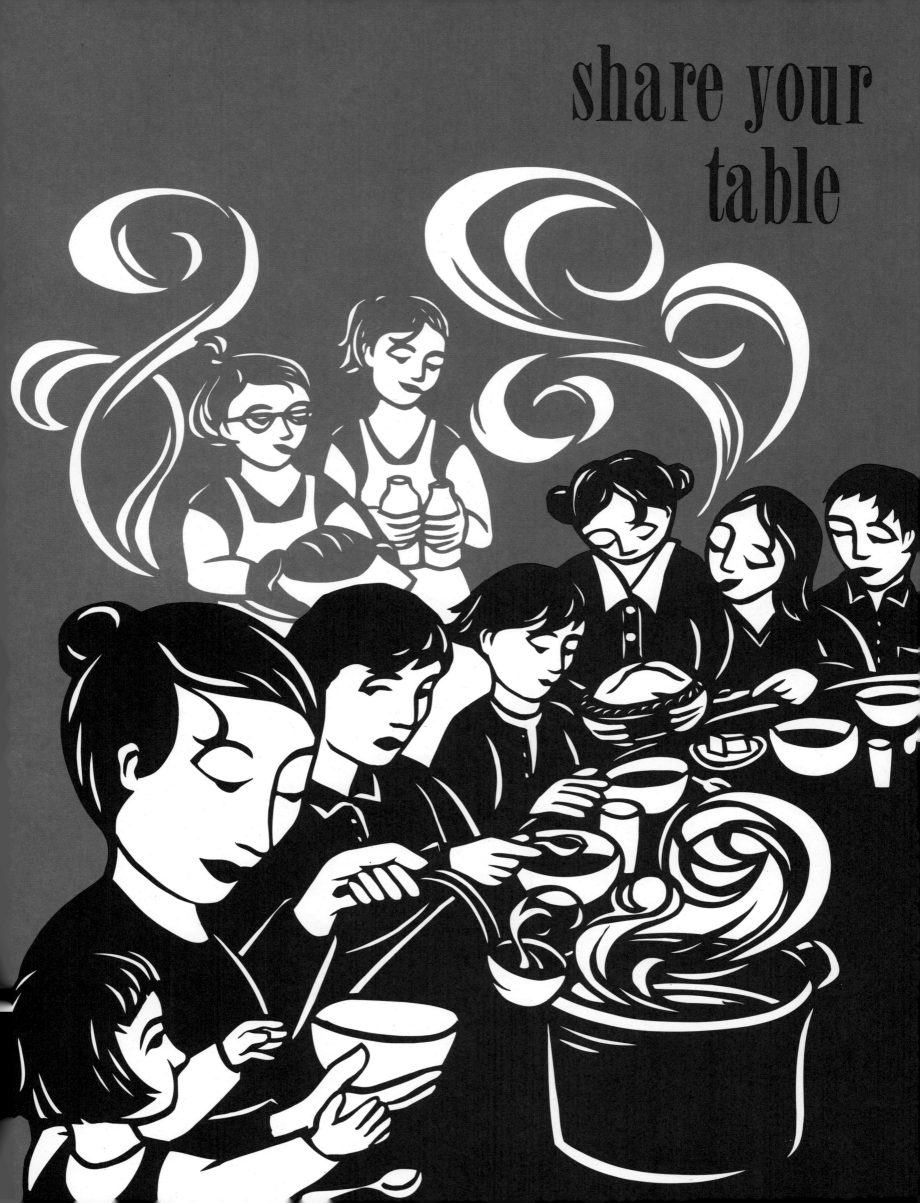

share your
table

work with care

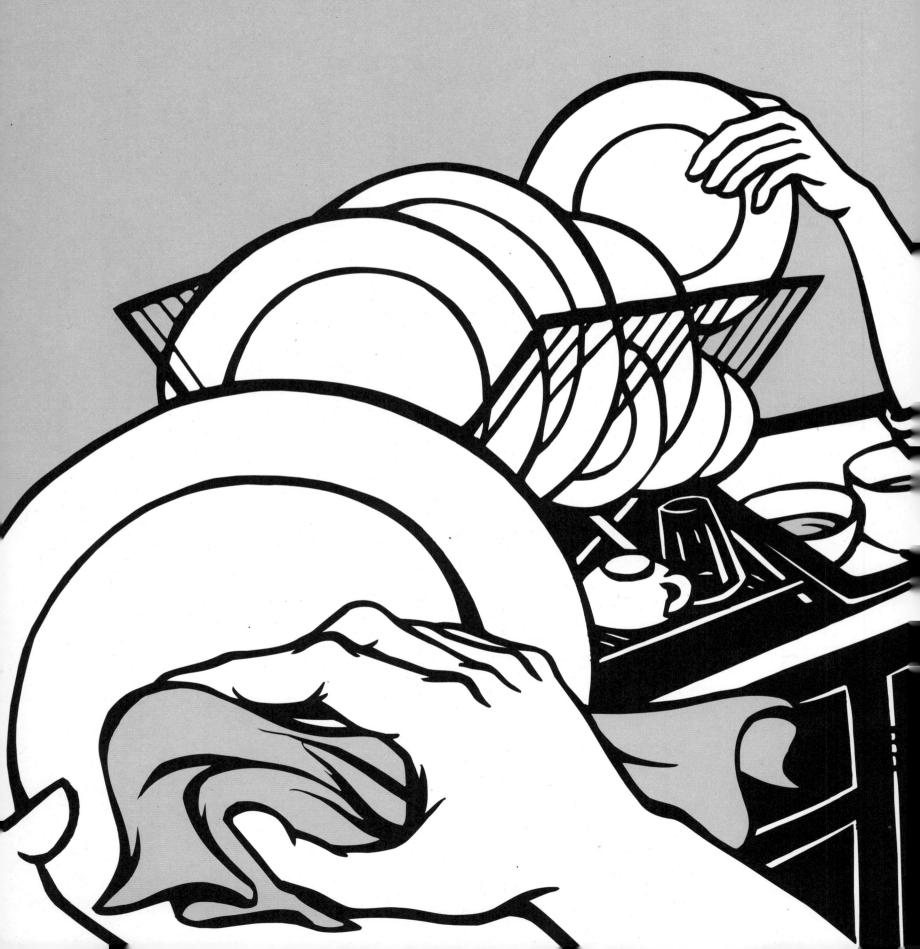

IMPART

defend civility

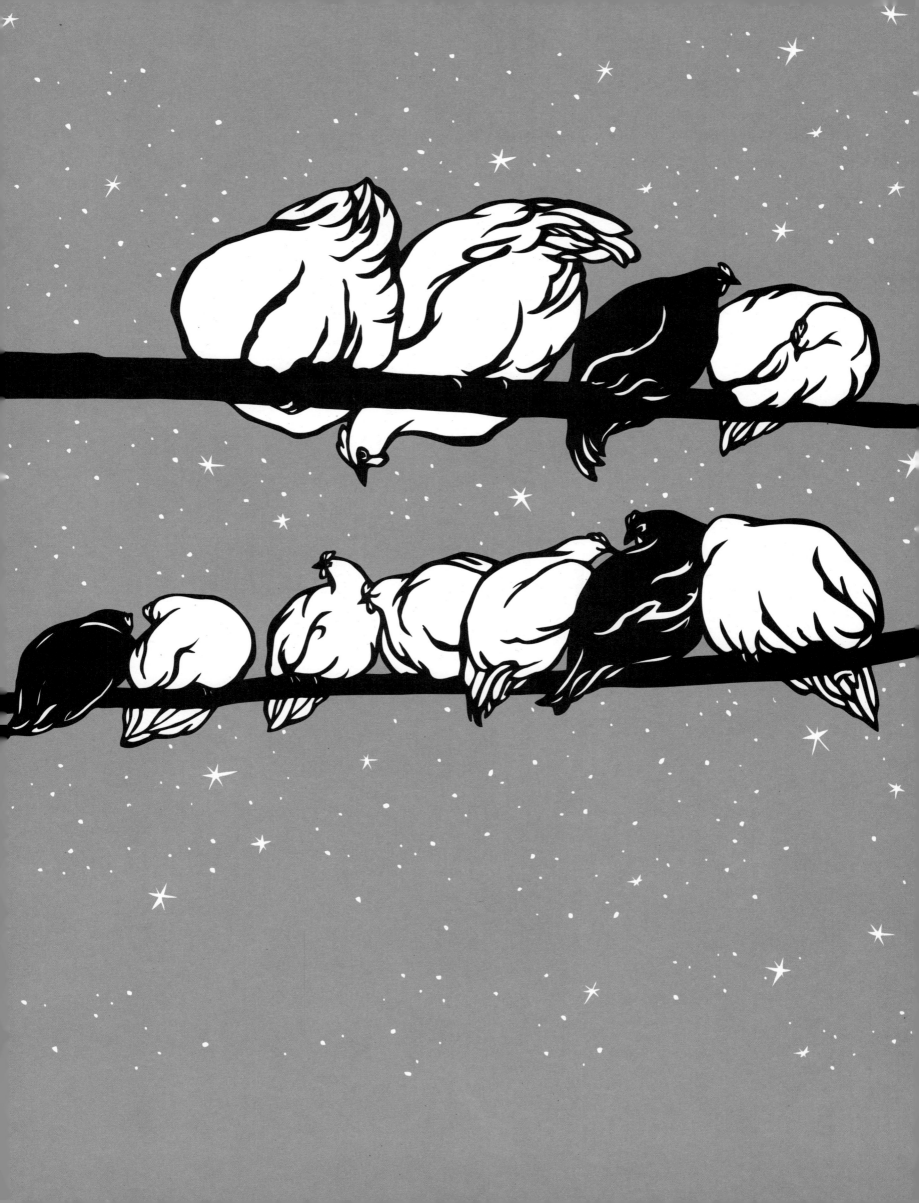

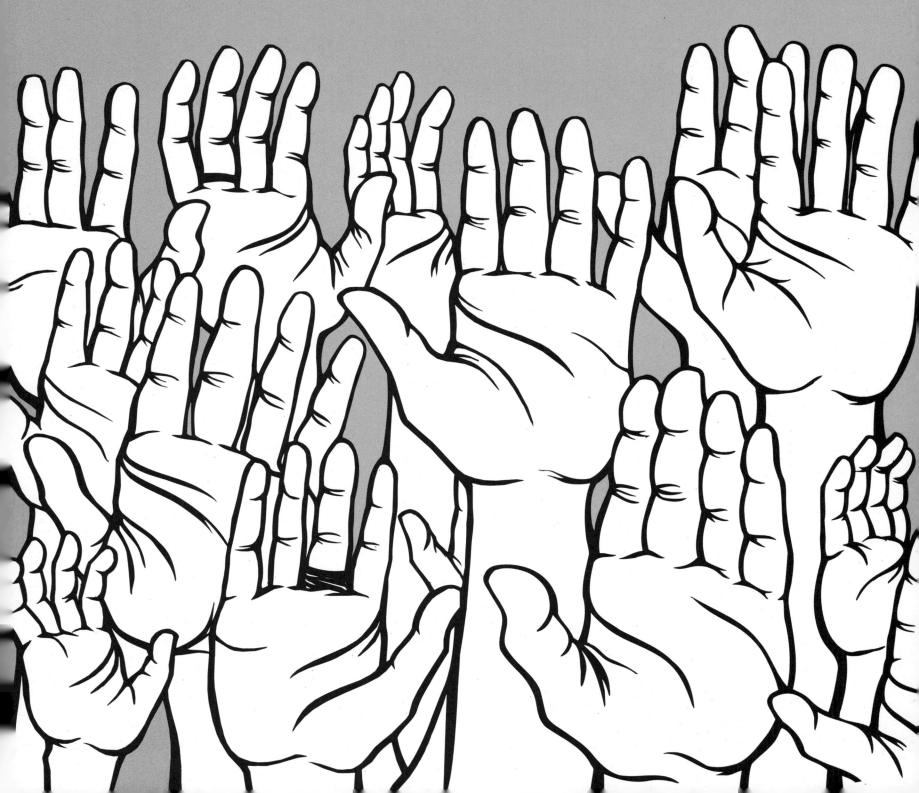

CAPSIZE

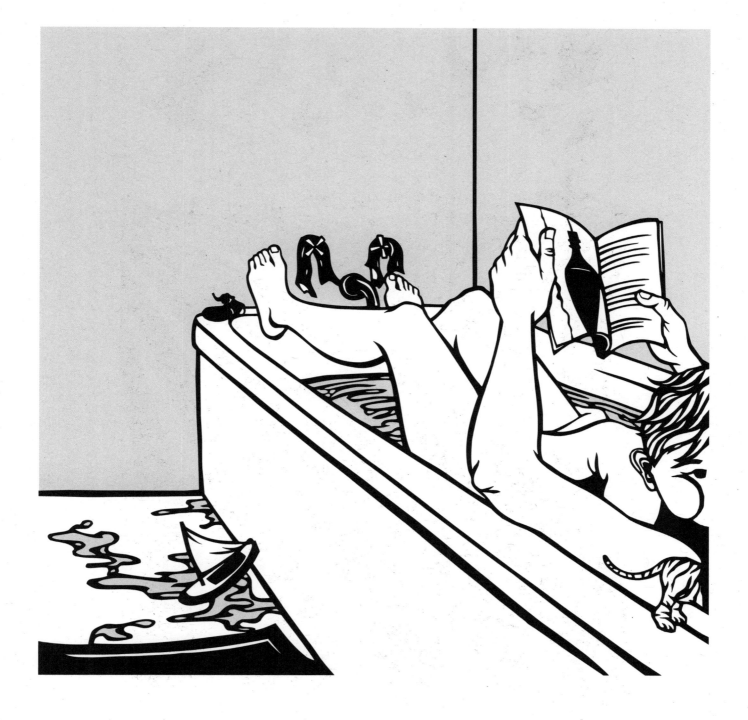

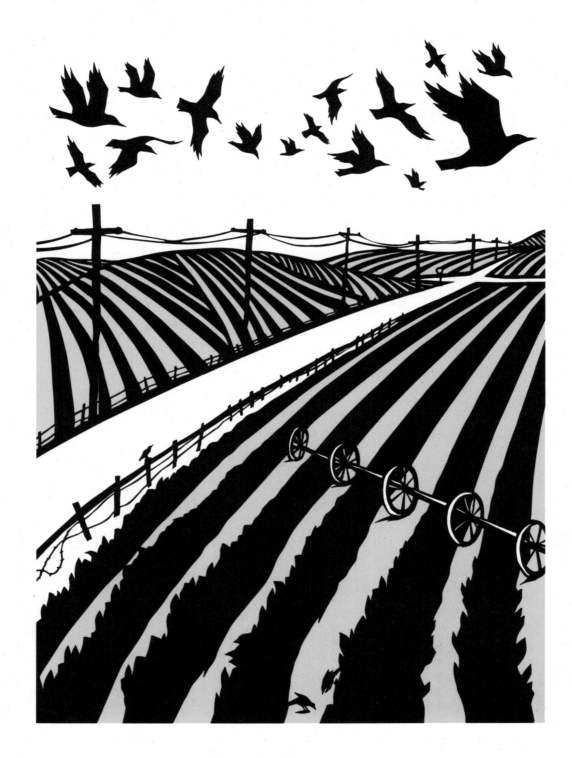

THANK YOU

After so many years of making calendars there are many people to thank: Pat Castaldo for too many hours on the computer and even more patience, Amber Bell for making any work party a factory and for her hairdo and friendship, South Bay Press for years of printing, Aaron and Pat at buyolympia.com, Tae Won Yu for suggesting that I try cutting paper, Stella Marrs for guidance, Calvin Johnson for the studio, Scott O, Mariella and K Records, Crimethinc Worker Collective, Amelia Davis, Maddie V.H.S., Khaela Maricich, Ariana Jacob, Mirah Zeitlyn, McCloud, Mark Wessell, Georgia Munger, Norio Fukado, Shari Basom, Reading Frenzy, Giant Robot, Otsu, Batdorf and Bronson's, Bryce's Barbershop, Bud the cat, Lois Maffeo and Eric Fleming, Ian MacKaye, the Crow-Lunsford Family and Anacortes swimming, The Chramiec's, Julie and Michael Burns, Lanny and Linda Carpenter, Miriam and Lena, Margery Sayre and Jocelyn Dohm, Cypress and Al, Calico Ocean Kicker, my Mother, all of Olympia, Steven Malk and Writer's House. Thank you all for your work and patience with me.

Thank you Eva Prinz, my editor at Harry N. Abrams who conjured up the idea of this collection and to E.Y. Lee for design and Anet Sirna-Bruder for her direction in producing this book.

Thank you to my family, Jay T. Scott and Finn, for all the support each winter, spring, summer, and fall.

Editor: Eva Prinz
Designer: E. Y. Lee
Production Manager: Anet Sirna-Bruder

Library of Congress Control Number: 2007299351

ISBN 10: 0-8109-9330-9
ISBN 13: 978-0-8109-9330-3

Text and art copyright © 2007 Nikki McClure

Published in 2007 by Abrams, an imprint of Harry N. Abrams, Inc.
All rights reserved. No portion of this book may be reproduced, stored in a retrieval system, or
transmitted in any form or by any means, mechanical, electronic, photocopying, recording,
or otherwise, without written permission from the publisher.

Printed and bound in Mexico on recycled paper
10 9 8 7 6 5 4 3 2

HNA
harry n. abrams, inc.
a subsidiary of La Martinière Groupe
115 West 18th Street
New York, NY 10011
www.hnabooks.com